North Notts College

PART OF RNN GROUP

NORTH NOTTS
COLLEGE
CARLTON ROAD
WORKSOP
NOTTS
S81 7HP

Date Of Return 9 APR 2009

Thank you for visiting our
NNC Library
To renew items, ring 01909 504637 or
Text Library to 07950080316

To renew items, ring 01909 504637

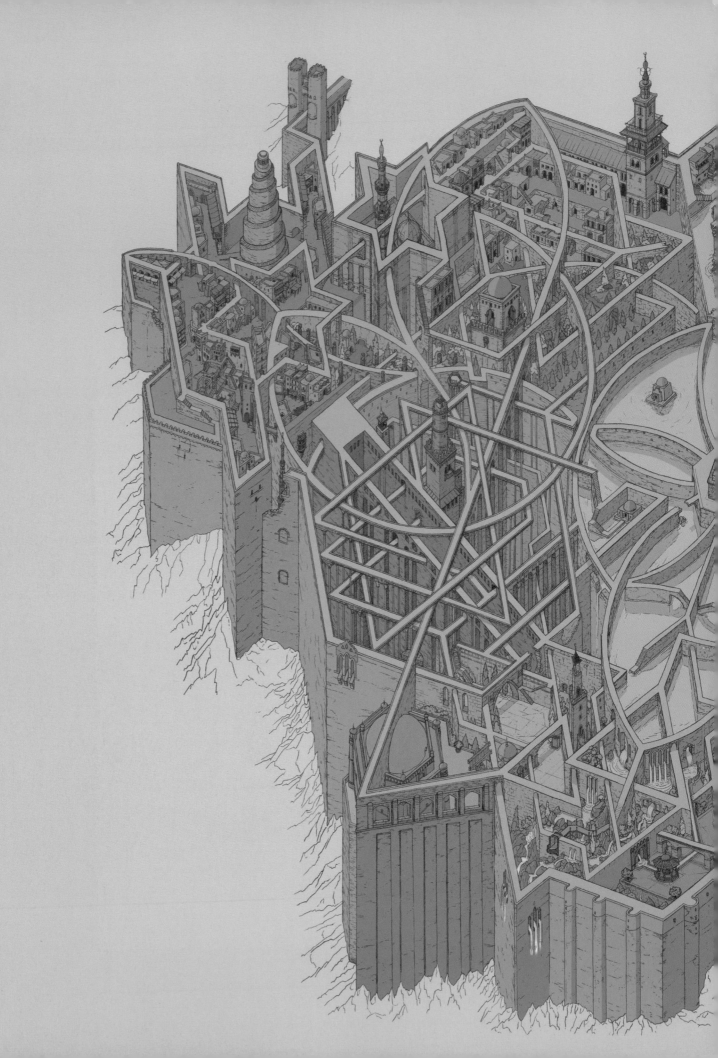

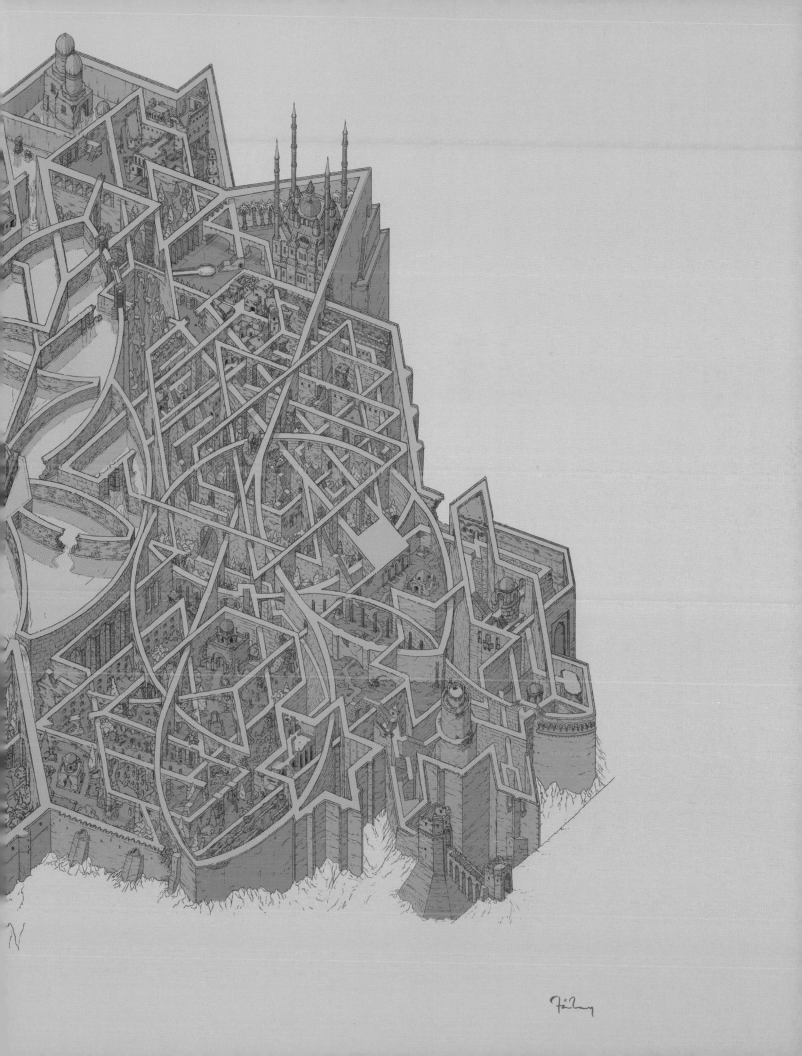

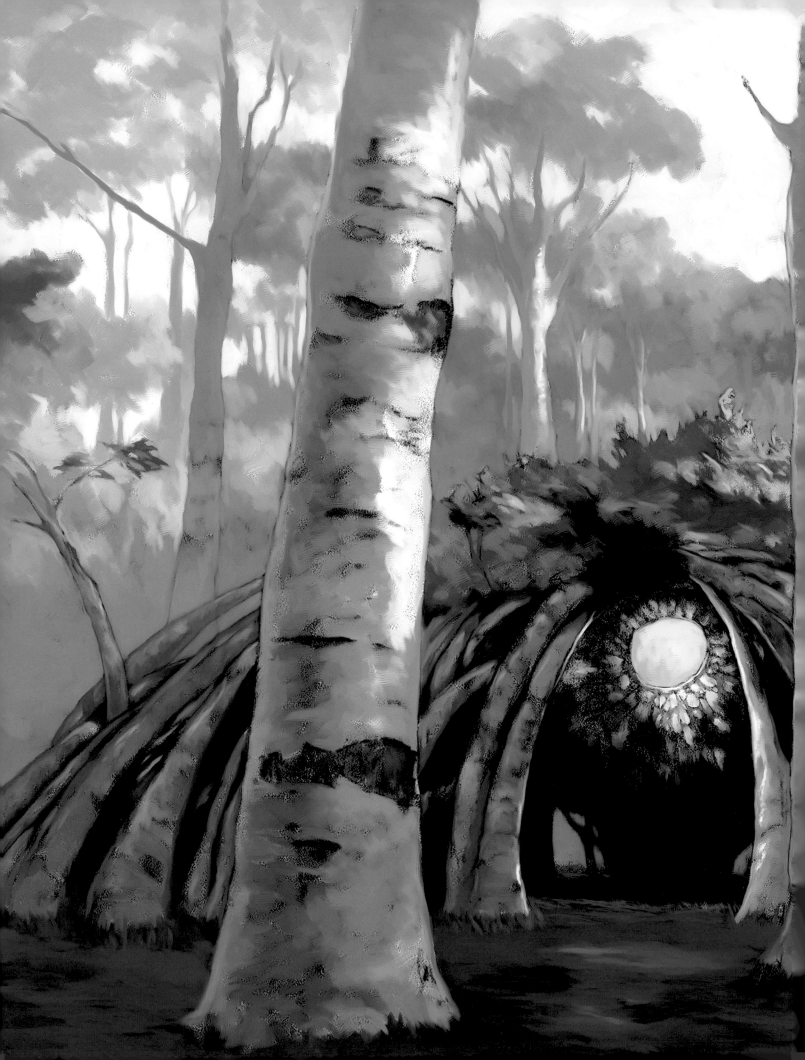

drawing & painting
Fantasy
WORLDS

FINLAY COWAN

IMPACT

AN IMPACT BOOK

IMPACT is an imprint of F+W Publications Inc. company
4700 East Galbraith Road
Cincinnati, OH 45236
Visit our website at www.impact-books.com

First published in the UK in 2006
First US paperback edition 2006
First UK paperback edition 2007

A catalogue record for this book is available from the
British Library.

ISBN-13: 978-1-58180-903-9 hardback
ISBN-10: 1-58180-903-4 hardback

ISBN-13: 978-1-58180-907-7 paperback
ISBN-10: 1-58180-907-7 paperback

Conceived, designed and produced for IMPACT
by David & Charles

Printed in Singapore by KHL Printing Co PTE Ltd
for David & Charles
Brunel House Newton Abbot Devon

Commissioning Editor Freya Dangerfield
Project Editor Ian Kearey
Assistant Editor Louise Clark
Art Editor Lisa Wyman
Art Editor Sarah Underhill
Production Controller Kelly Smith

Visit our website at www.davidandcharles.co.uk

David & Charles books are available from all good
bookshops; alternatively you can contact our Orderline
on 0870 9908222 or write to us at FREEPOST EX2
110, D&C Direct, Newton Abbot, TQ12 4ZZ (no stamp
required UK only); US customers call 800-289-0963 and
Canadian customers call 800-840-5220.

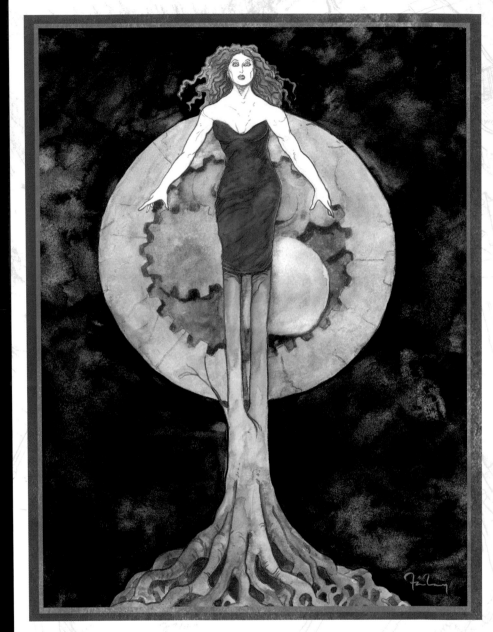

This book is dedicated to:
Janette Swift – for making my life what it is
and
Lisa Wallden – I didn't have enough time with you,
but you'll be with me forever.

Contents

Introduction

**fantasy (n),
from the Latin 'phantasia'**

1 Imagination. The process, the faculty, or the result of forming representations of things not actually present (1553).

Myth

'A myth is not a fiction but a structure to express elusive experiences or share philosophical ideas.'

Alan Fletcher

The psychologist Carl Jung described archetypes such as the Hero, the Magician and the Wanderer as having come from the 'collective unconscious' of the whole human race. Since the earliest times human societies all over the world have had comparable attitudes to sex, birth, the supernatural, and life and death in general, and humankind has used strikingly similar images to represent those attitudes in stories throughout history and into modern times. For example, part of the remarkable success of the *Star Wars* films is due to George Lucas's respect for and understanding of these themes and ideas.

Archetypal fantasy stories and images have been evolving for thousands of years, and these stories tell us something about how to live our lives and function within society. At any given time or place in history, myths and legends reflect the hopes and fears of the people in that society. The modern fantasy artist has the pleasure of being able to explore the many versions of the great epics and quests that have been recorded before he or she came along, and it is his or her task to shed new light on these ancient themes and retell the old stories in such a way that they make sense to modern audiences.

We live in a world where fact rules: everything we do is measured by how many facts we have learned, what exams we have passed, how much money we have made. Everything we do is reduced to statistics, and these are considered to be truth.

Fantasy, myth and stories as a whole offer us a different way of looking at things. These stories invite us to use our imagination and deal with the unpredictable, uncontrollable and unknown – all the things that can't be measured with statistics. These stories allow us to walk the line between what exists and what we think might exist, and this has allowed them to survive beyond the cultures where they originated.

Consequently art and its function of storytelling operate at the extremes of possibilities; it is the job of the artist to amaze and surprise, and to offer the unexpected as well as to redefine the classic imagery and formulas of myth.

Fantasy archetypes

The archetypal hero is the male or female character who sets out on a journey that takes him or her away from everything familiar. It is said to be symbolic of the passage from childhood to adulthood, where people become responsible for themselves, their actions and the world they live in.

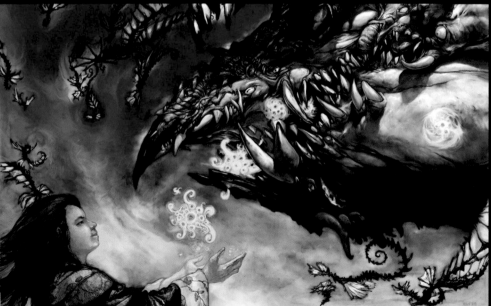

While undertaking his quest, a hero will invariably be expected to face seemingly insurmountable obstacles, problems he never dreamed himself capable of dealing with. This is most often represented in myth by gargantuan monsters and demons.
Petals of Insight by Anthony S. Waters; © 2005 Wizards of the Coast, Inc. Used with permission

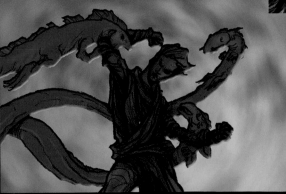

In order to achieve their goals, heroes often have to confront their own inner demons, a metaphor that is taken literally in the fantasy genre.

The artist's journey

Whether you are the caveman by the campfire or the director at the helm of a multimillion-dollar blockbuster, you are doing the same job. The only difference is that the director needs to have practical experience of a multitude of skills to do the job, while the caveman needs only charisma and the ability to grunt and wave in an engaging manner. Nevertheless, the classic art of storytelling has retained its central place in all human cultures, and, as a fantasy artist, you will join the procession and pass on your stories and visions as others have passed them on to you.

For this reason, the artist's journey mimics the classic idea of the 'hero's journey', the basic adventure we see played out in books and films. Joseph Campbell described this: 'The main character is a hero or heroine who has found or done something beyond the normal range of experience. A hero is someone who has given his or her life to something bigger than themselves.'

And as you go along in search of something, you run into obstacles and there are times when the world seems to be against you. There are other times when it seems pointless to continue, or when doubt creeps in and you may feel that it's all been a huge mistake. These are all experiences that our favourite heroes and heroines go through, so it's hardly surprising that, once we have begun, we have to continue, come what may.

You love to draw, you love to paint. You probably love to dream. And why not? Tolkien and C.S. Lewis were people just like you or me, and their achievements were those of dreamers. If you believe it, it's possible. Even if you don't succeed, you will at least learn some remarkable things along the way.

We all have dreams, and sometimes dreams can come true. The film and computer game industries rely on dreams to survive, so it's not necessarily a bad thing to be a dreamer ... just make sure that dreaming is not all you do. Being a fantasy artist is about turning your dreams into realities ... every day.

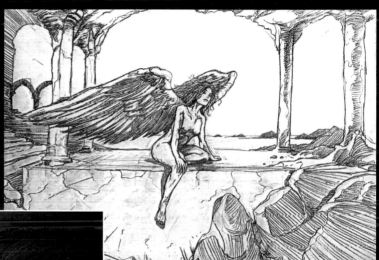

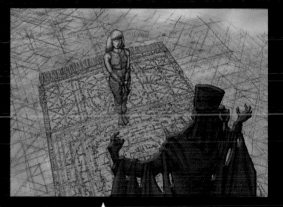

Powerful mythical icons include the winged angel, referring back to the Christian tradition.

The dark lady has echoes of the Zoroastrian entity known as Lilith.

Lilith of the Skulls by Bob Hobbs

Knowledge, truth and power are just some of the concepts symbolized by the use of talismans, amulets and other sacred objects.

Dark forces are said to represent the ills of society, including everything from warfare to disease. They can also reflect an extreme aspect of our own psyche.

Classic scenarios resound throughout the genre, such as the not-so-helpless female at the mercy of the mad magician.

Another classic scenario, the showdown, results in the demise of the villain and often leads to a change from dystopia to utopia.

How to use this book

The first aims of most artists are:
- to get their ideas together
- to get those ideas across

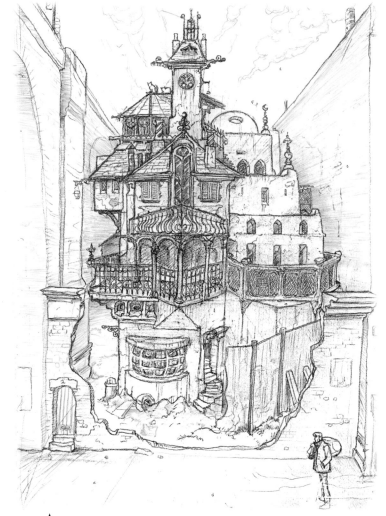

Because of these, the aim of this book is twofold: first, it follows the process of how to have ideas, how to develop them and how to organize them into a structure. You will find a lot of questions and tips designed to trigger your imagination.

Second, I have aimed to cover all the basic practical aspects of getting your ideas across. There is not enough space in this book to turn you into a master of oil painting or computer game design, but you will find that all the building blocks for designing and communicating your ideas are here.

The fundamental approaches to art and design remain the same, irrespective of changes in technology and fashion, and it is these principles that this book focuses on; how the artist chooses to execute work is a matter of personal choice and circumstance.

You can use this book as a checklist to make sure you have considered all the various aspects of designing a fantasy world; it is full of useful pointers for when you run out of ideas or are struggling with the technicalities of executing those ideas.

In the course of writing this book I looked back over my career as an artist and tried to remember all the biggest practical obstacles to my artistic development – all those little tricks and techniques for expressing places, objects and people – and I have tried to give the solutions to most of those problems here.

Character development
How to turn your anatomy drawings into believable fantasy characters.

Inspiration
How to find it and what to do with it when you get it.

Creatures
Creating hordes of ugly, slug-faced slimeballs ... and some pretty ones too.

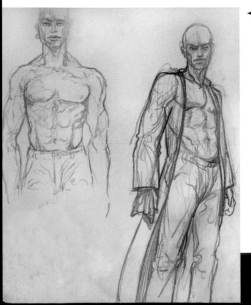

Anatomy
Anatomy can be tough to learn; if you like, go first to the chapters on architecture and beasts, which you might find easier, and then come back to figures.

Watercolours
Working with watercolours to produce finished artworks.

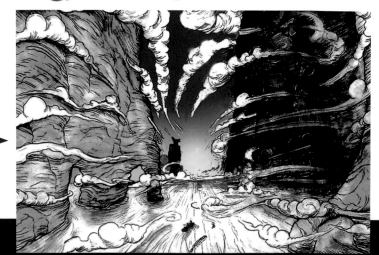

Working digitally
Basic and advanced tutorials covering 3D and digital techniques.
Zazel by Bob Hobbs

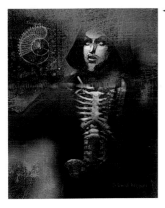

Hardware
Techniques for researching, inventing and drawing your machines, vehicles and weapons.

Perspective drawing
Learn how to introduce exciting dynamics to your places, objects and figures.

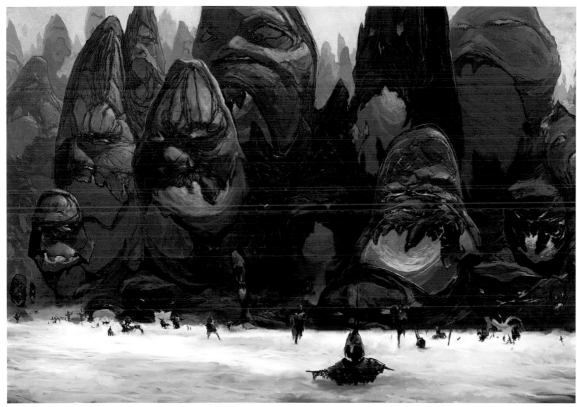

Fantasy worlds
A guide to the many considerations and possibilities of designing worlds, environments and architecture.
Cinder Wall by Anthony S. Waters; © 2005 Wizards of the Coast, Inc. Used with permission

Step-by-step guides
Detailed analysis of the process of producing a variety of artworks, from pencil to digital.

Getting results

When I watch my young son attempting to draw something he's seen in *The Lord of the Rings*, it's obvious that he wants to be an absolute master of the craft in ten minutes – that's understandable: don't we all ? – but this is unrealistic, and deep down he knows it. Nevertheless, more than anything he wants to get a result, fast. He's inspired and he just wants to get his ideas across. That is what this book is mostly about: it's full of methods for doing all the things you could want to when it comes to creating fantasy worlds.

Beyond that, there is more detailed information and techniques that might be much harder to achieve. Don't worry if these areas are difficult or hard to understand; we've tried to put them across in such a way that you can at least get a taste of what is possible in the long run – the heights you can go to from starting with the basics.

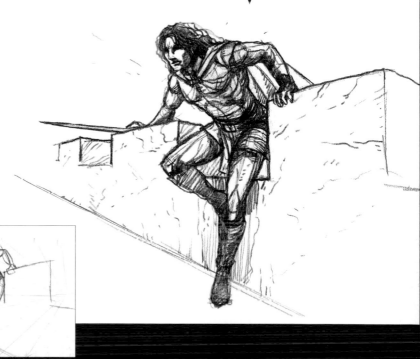

Basics

'Order and simplification are the first steps
towards mastery of any subject.' THOMAS MANN

We are all storytellers, some of us just don't know
it; some have the talent to tell a story but not to
record it; and others have no desire to put it down
in writing or drawing. But if you are reading this
book, the chances are that you have some innate
desire to record some of the wonderful visions
you see in the world around you, and other, more
fantastic visions you have seen only in your dreams.
One of the biggest challenges is knowing where to
begin. It is important to pay attention to organizing
your workspace and your research materials so that
you can approach your work with the right tools to
hand, both material and intellectual.

The workspace

Most artists build up their own studio over a period of time, and each artist has a personal way of working and organizing space. For the beginner there are a few basics that can be considered, but it is important to realize that you do not need everything to begin with – I worked for many years with nothing but a sheet of wood propped up on some books; it was only later that I graduated to computers and all the other peripheral equipment and furniture that comes in useful for an artist.

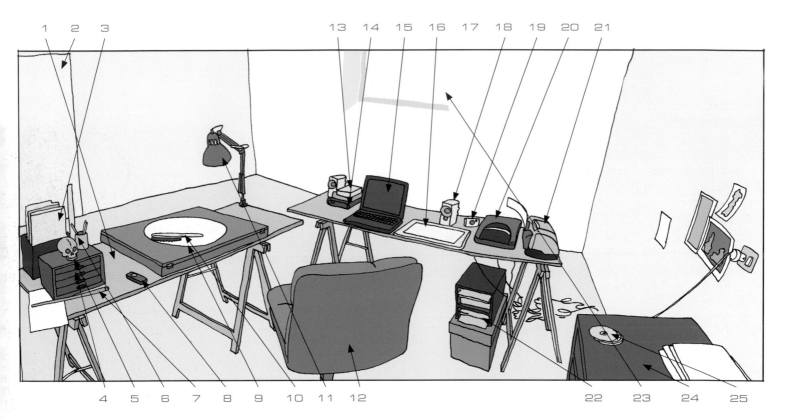

1 Trestle tables
The simplest and cheapest form of table, easy to arrange and organize.

2 Door
This leads to a big, scary thing called the Outside World. Most fantasy artists avoid using this unless absolutely necessary.

3 Job files
A simple filing system for keeping sketches and notes for different jobs in order. Jobs usually overlap, and it is helpful to keep files of details that may be forgotten over a period of time.

4 Small plan chest
For pencils, erasers and other small art equipment. Must be within easy reach at all times.

5 Skull
To remind us that all this is fleeting. Not an essential item, but quite common among fantasy artists.

6 Ruler and tin with pens and pencils
Drawing materials should be easily accessible at all times, but should not be left lying around on the desk, where they can get damaged.

7 Swagger stick
First World War memorabilia, useful for pointing at large artworks and impressing clients at the same time.

8 Phone
Tenuous link with the Outside World – to be used carefully and wisely.

9 Lightbox
This essential item has a revolving panel, lit from beneath, and tilts upwards as a drawing board. Useful for doing clean line drawings from roughs or for tracing off other images.

10 Brush
A soft one is useful for sweeping eraser detritus and dust off delicate artworks.

11 Anglepoise lamp
A good, strong light source that can be moved around is essential. When working on detailed artworks, the shadow of your hand can get in the way, so a movable lamp is very helpful.

12 Funky 70s-style office chair
Actually, it might be more advisable to get a nice sensible office chair that will

support your lower back (see box at right). If you are going to spend a lifetime doing this stuff, it's worth getting a good office chair that will support your lower back, encourage you to sit up straight and keep you comfortable.

13 External hard drive
Although your computer's hard disk may have ample space, it is advisable to use an external drive for backing up in case of computer failure, fire or theft.

14 External CD/ DVD burner
Most new computers have these built in. CDs and DVDs are essential for sending work to clients, printers and so on.

15 Computer
Some artists still work without computers … but I have to say I don't know any. Most of my work is produced by traditional methods, but I still find the computer essential for taking care of business and getting my work seen.

16 Graphics tablet
This wonderful invention allows the artist to use a pen-shaped 'stylus' instead of a mouse. The pad is pressure-sensitive and very easy to use, allowing the artist to draw and paint directly into the computer. Nobody who uses one ever looks back.

17 Broadband connection
Not essential, but this is becoming a common way of sending artworks to printers and clients quickly, without disrupting phone lines.

18 Stereo speakers
It's going to get very lonely in the workspace at times. You'll need some entertainment – preferably of your own choice.

19 Digital camera
Helpful for collecting reference imagery and textures for using in your artworks.

20 Scanner
Most desktop scanners provide print-quality scans. Don't get the very cheapest as they tend to work very slowly; aim for something mid-range.

21 Printer
The cheapest tend to be slow; aim for something mid-price. Printers are cheap, but be prepared to be robbed blind when buying ink look for commercial refillers, particularly of coloured inks.

22 Paper store
Keep a variety of printer-friendly papers within reach of the printer; use cheap and recycled paper for general everyday use, and save the glossy stuff for prestige clients. Keep test copies and use the flip side for notes and doodles later on.

23 Window
Not essential, but useful for staring listlessly out of when deadlines are looming. Allegedly, sunlight is good for you too, unless you are of the purely nocturnal species of fantasy artist – you know the ones I mean.

24 Plan chest
In addition to the small, desk-sized version, a full-size one is very useful for storing valuable comic books and collections of movie posters … and occasionally artworks as well.

25 Blank CDs
The most widely used and efficient way of getting your work to clients and printers. Leaving them lying around in direct sunlight without slipcases, as I've done here, is the best way to ruin them.

Looking after Number One
If you are always hunched over your work or computer, you will eventually damage your spine, and this can be very painful. If you are comfortable and free from the pain of a bad back or neck, you will be able to work for longer periods and get more done, and life will be much easier. A simple thing like a good chair can revolutionize your working life and change the way you feel about what you do. Being hunched up may not hurt now, but it will!

Ideally, your computer screen should be higher than desk height: you shouldn't be tilting your head down or forward too much. Your hands and forearms should be supported (put padding on your desk for this). The way you set up your computer is dependent on your chair as well, so you have to organize the two together to get the most comfortable combination.

It can be good to have natural daylight on your work. It can also be nice to surround yourself with objects and furnishings that make you feel comfortable – the more time you want to spend at your desk, the better.

Wouldn't it be great, however, if computers had legs and could just scuttle around after us?

Designed by Tyler Swift-Cowan

Materials

Artists have a wide range of materials to choose from, ranging in price from eminently affordable to exasperatingly expensive. Some things you can't skimp on, such as computers and software, but other items, such as pencils and paper, can be found very cheaply, and you may never need to buy the very best unless you want to.

Pencil and paper

Try out several different pencils of varying hardness; you will soon find that some are better for detailed work and others are better for tonal work. Try other media such as charcoal and conté to explore new possibilities.

There are many different types of paper. I use cheap photocopy paper for general use and cartridge paper for better texture and tone when drawing in pencil. I often use watercolour paper for pencil work because I like the variety of textures available, and you can also experiment with handmade papers, such as the authentic Egyptian papyrus used in the example on the left.

Pen and ink

For ink work you can use brushes, pens or special quill pens, which take some getting used to but can be valuable tools in the long run. It is always a good thing for an artist to be able to handle a brush, as this will add to your skill set and adaptability. Smooth, hard Bristol boards are considered the best for pen and ink, and for marker work you need specialist bleedproof papers.

Painting

Since early humans started daubing the blood and dung of animals (and that of their enemies) on the walls of their caves, pigment paints have been the medium of choice for fantasy artists. The techniques involved in the use of paint have had several thousand years to develop; they apply to all forms of painting, and it would be impossible to go into detail on the subject in the space available in this book. Students wishing to master the techniques of oil and acrylic painting should be prepared to spend years studying and practising their craft and look closely at the work of other great fantasy painters through the ages.

Digital painting

In recent years digital technology has ushered in a new form of painting, which has raised the question, where does painting end and digital begin? The technology that artists are using today has reached the stage where the definition has become blurred – if you look at the work of Anthony S. Waters in this book it becomes hard to tell (he certainly had me fooled). By comparison, Bob Hobbs, whose work is also featured throughout this book, has used the great variety of software available to pursue a style that embraces all the possibilities of a new art form. So it seems that the time has come to consider digital art as a valid form of painting in itself.

Goblin Mines by Anthony S. Waters;
© 2005 Hidden City Games, LLC.
Reproduced under license

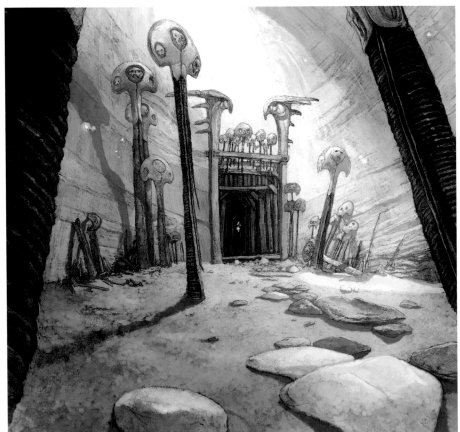

Graphics, photography and mixed media

With the advent of digital photography it has become much easier for the artist to create

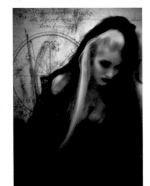

subtle blends of photographs with illustration in other media, scanned texts and computer-generated textures to create all types of sumptuous fantasy imagery.

Stabs in the Dark by Bob Hobbs

Digital 3D

After clumsy beginnings, the art of 3D modelling has developed into a huge industry, taking in animated feature films and computer games. Many beginners are finding that the software required to create their own animations and games is now becoming more accessible and easier to use with each passing generation of computers. The producers of professional modelling packages such as Maya and Lightwave have made their products more affordable in order to compete with newer, cheaper entries into the market, such as Poser and Vue d'Esprit, encouraging a new generation of artists to turn their attention to this rapidly evolving art form.

Computers

The choice presented to artists making their first foray into the hallowed realms of digital is enormous, but there are a few 'industry standard' programs that all digital artists tend to use, such as Photoshop, Painter for painting, Illustrator and Flash for graphics and web design, and Maya, Lightwave, Poser and Vue d'Esprit for 3D.

Choosing your machine

In the old days – about two or three months ago – it was important to check on every new piece of software what its 'system requirements' were; it would be common to find that your computer didn't have enough speed or memory to cope with a certain application. Nowadays, most computers are capable of running most applications, with plenty of available space on the hard drive for storage.

Digital design

It is very easy to be distracted into using the techniques made available by software, rather than finding a way of getting the machine to do what you originally set out to do. This results in a lot of computer-generated art tending to look very much the same – the equivalent of being tempted by the dark side and turned into a mindless servant of the dark lord of cyberspace. Make sure you know what YOU want to achieve before turning the computer on – make sure that the machine is your tool, not the other way around.

Witch Table by Bob Hobbs

Digital morality – a warning

'Copyright' is the word used to define the ownership of a creation by an artist, whether it is a design, music or writing. If you copy, scan or trace somebody else's image you are technically breaching copyright and this is illegal.

However, for the purposes of learning it is OK to copy, trace and scan other people's work, just as long as you don't pass it off as your own or make money out of it. Furthermore, I would encourage readers of this book to copy the images in it, especially if you are having difficulties with the way things are done. So, feel free to trace the examples just as long as you refer to the original artist when you sign your versions and show them to others.

That's roughly how it works, although the world of copyright is complex, and it is worth looking into when you start to go about selling your work.

Equipment and software used by the artists featured in this book

Finlay Cowan
- Pencils, paper, erasers
- Apple Mac G4 PowerBook, Superdrive, 17in screen, running OS X
- CPU running at 1.6GHz with 512MB RAM
- Wacom Intuos2 9x12 graphics tablet
- 380GB external storage
- Epson Perfection 1670 scanner
- Epson Stylus Photo 890 inkjet printer
- Digital camera and video
- Watercolours by Schminke

Software used:
Adobe Photoshop

Bob Hobbs
- Compaq Presario 5000 with Pentium 4 running Windows XP Home Edition
- CPU running at 1500MHz, 1.5GHz with 512MB of RAM
- NVidia GeForce 2 MX graphics card
- Wacom 4x5 Digitizer tablet with pen and wireless mouse
- Simplex DP30f scanner
- 160GB of storage space including 120GB external hard drive
- 100MB Iomega Zip drive

Software used:
Adobe Photoshop 7
Poser 5
3D Studio MAX 5
Vue d'Esprit 4

Anthony S. Waters
- Pilot disposable pens
- Ballpoint pens and pencils
- Epson Expression 636 scanner
- Apple Mac G4 Dual 500 with 1GB RAM and 9.1GB dedicated scratch disk
- Sony Trinitron 19in monitor
- Wacom Intuos2 6x8 graphics tablet

Software used:
Adobe Photoshop 6
Corel Painter 8, sometimes 6 and 7
Synthetik Software Studio Artist

Research and inspiration

'What are your influences?'

Everything can be an influence. As you walk down the street you are assailed by impressions, sights, smells, sounds, light and shade. As an artist you can try and find a state similar to that of childhood wonder, where you are open to everything – always ready to see a familiar thing through new eyes. If you are lucky, the world changes every time you blink – I can look at the tree outside my study and every day it is different. But what happens on those days when you are staring at a blank page and don't know where to start?

Inspiration

Art requires ideas, and ideas are born from inspiration, and this can come from two places.

The first is an emotional response to the things we see around us, the things that touch us. Artists, musicians, writers and other creative people, such as scientists and entrepreneurs, are often compelled to create something because of an event that has taken place in their lives. This has somehow fired their emotions and driven them to act as a result of it, and very little will stop them achieving their goal. But this emotional urge is not restricted to big ideas and grand gestures; people use it every day in smaller ways, such as the artist who is inspired by the dark beauty of a factory to paint a fantasy city.

Be aware of what moves you and make notes on it so you can go back to them later and fire your imagination. Be aware of what the people in your life say and do that moves you, whether they make you angry, happy or sentimental, and keep a record of these moments for future reference.

But life cannot be all emotional insights; artists must also refer to more practical means of feeding their imagination, and this is where the grand subject of research comes in.

Research
The Internet

For several thousand years information was controlled by people in power. As a result, information and knowledge conferred power and were generally used to control people and keep them busy while the people in power had a good time. This situation began to change with the invention of the Internet, a system of making information available that can't be controlled and manipulated for the interests of a ruling minority. This means that you and I can research to our hearts' content and decide what we think is true and what isn't.

Unfortunately, there is a downside to this: the Internet has been swamped by a vast amount of useless and meaningless information, which has no thorough research or proof to back it up. The Internet is a great place to graze for ideas, but you are advised to cross-reference information and find sources that take a differing viewpoint and provide alternative evidence.

Library

If the Internet doesn't satisfy, go to the library. Some people think reference books are boring, but in the eyes of the artist who is looking to change real-life situations into fantasy

You can be continually inspired and influenced by being open. If the art doesn't come from you, it comes through you.

Some of the best research areas for fantasy artists are:

- Architecture (ancient and modern)
- Ethnography, anthropology, costumes of peoples of the world
- Geography
- General encyclopedias (the drawback with these is that they can be too general, but they are a good start)
- Military history
- General history – stories and histories of people that are wilder than anything you might imagine. For example, try looking up Queen Ranavalona of Madagascar during the mid-1800s – the subject of just one of innumerable amazing stories waiting to be fictionalized
- Science and astronomy (ancient and modern)
- Myths and legends – essential in terms of understanding what 'fantasy' is all about
- Books and comics on fantasy art – use these for inspiration and technique rather than for finding ideas

You can start to build up a collection over a period of time. You may want to divide your research up into separate areas, such as classical architecture, eastern architecture, surrealist painting, classical ornament and eastern ornament. The list could go on and on, but it is up to the individual artist to decide in which areas he or she feels the need for the best reference.

situations, they are a fertile hunting ground. The more you use libraries, the easier it gets: what may seem dusty and dreary at first starts to sparkle with possibilities when you develop the knack for creating a vision of things in your mind's eye. For example, a typical history book describing the political climate in Rome after the death of Marcus Aurelius could be a rather dull read – but that's exactly what the writers of the hit movie *Gladiator* sat and read for a couple of years before writing their script. You must learn to do the same – don't wait for a Hollywood movie to make it look good for you: do it yourself.

Books

Books have two advantages over the Internet: you can get to know a book – certain collections of images and text become more and more familiar to you the longer you use them; and the information becomes a specific and unique part of your artistic toolkit.

Over the years you will develop a talent for finding books that suit you; you will develop your own unique style and outlook, which is informed by the collection that you gather. You will also find that your interests overlap with the interests of others, and books are a great way of exchanging cultural ideas and values.

Museums

Although it's easy to find material in books or on the Internet, there is nothing quite so inspiring as seeing it at first hand in 3D. It can take quite a lot of time and patience to sit and draw in museums, but digital photography without a flash is usually permitted. Some collections are breathtaking and can have a tremendous influence on our work, as we realize that truth is often far stranger than fiction.

Museums usually have a large collection of postcards for sale, which are a cheap and effective way of gathering a collection of interesting material together without having to buy lavish museum guides.

Mentors

One of the great overlooked resources for artists is that of the mentor figure. Build the confidence to communicate with older people who might have vast libraries of fascinating images and information – the

local architect or a history teacher or less obvious choices – and be aware when you meet people who are interested in the world, its people and its history. In a few words a person can explain and clarify a whole book's worth of information, and older people in particular carry with them a lifetime of experience and wisdom that could save you a great deal of trouble finding out for yourself.

Other artists and creative people

It's good to communicate with other artists, especially those with skills different to yours: I'm not very good at technical manuals, as my brain finds it hard to deal with them, so by a natural process I have surrounded myself with the type of creative person who is technically minded and can explain things to me. Sometimes you can make more progress in a single call to a friend than you can in three hours reading a manual. Conversely, I am useful to them by being much more lateral and abstract than they are, so we work for each other. You can gradually make contacts all over the world – I have never met or heard the voices of the two artists with whom I am working on this book – and this will build into networks that will support you throughout your working life.

Mementoes

I've been collecting mementoes all my life – cheap oddities that I pick up in junk shops. These can be anything from a small bronze statue, a cast of a child's skull, bullet cases, medals, coins and ornaments to a particularly beautiful pine cone or a piece of ornate fabric. I don't often use them directly as reference for my work, but every tiny object tells a story.

Sketchbooks and scrapbooks

As you collect clippings from newspapers and magazines it may become difficult to remember what you've got, so start scrapbooks. Just stick them all in any old how. Add your doodles and scribbles into the books, and odd bits of packaging and graphics, no matter how irrelevant they may seem.

A sacred space

Your work station is your 'sacred space' – a place where you are cut off from newspapers, your friends, television or anything that usually occupies your attention. It's a place of creative incubation, but at first you might find that nothing happens. You sit down, probably in front of your drawing board, and you are all fired up to produce a masterpiece ... but nothing happens. However, eventually something will happen, if you give it time.

It may appear that you are not doing anything for the time being, but don't worry, there is an idea forming inside you somewhere. So, for your first exercise, just find your 'sacred space' and do nothing for a while, wait and see what comes.

Figure drawing

Almost every aspect of the whole genre of fantasy is about exaggeration. Everything we see is bigger, faster, wilder and weirder than anything that came before. This rule may ultimately affect every aspect of your work, but before you begin to break the rules it is important to have an understanding of which rules you will be breaking. Human anatomy is perhaps the most challenging area of art and may prove to be frustrating and difficult at first, but with time and experience you will develop your own unique style and approach to an area of art that has absorbed artists since time immemorial.

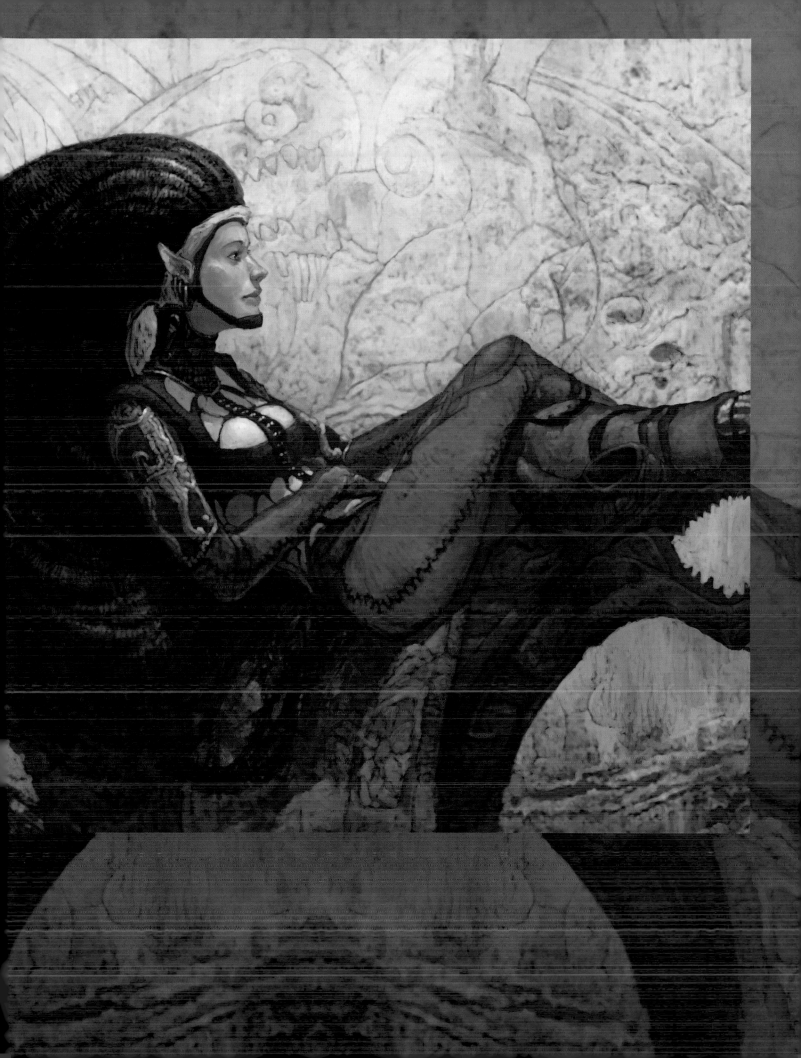

Basic anatomy

There can be no substitute for life drawing, no matter how many books you buy that show how to construct figures from a series of shapes or volumes. Making observational drawings from real life, whether in a class or on the street, develops artistic skills that are far deeper and longer-lasting. Nevertheless, life drawing is a long-term activity, and there are a few simple methods that will get you going on the road to mastering anatomy.

The human skeleton

Although you won't need to draw skeletons all the time, it's good to have an understanding of the basic architecture of the human body. As you develop your skills as an artist, you may wish to return to study anatomy in more detail. To begin with, practise by copying or tracing this skeleton to help familiarize yourself with the basic joints and bones of the body.

Male and female proportions

The head is most often used as the unit of size. Leonardo da Vinci was the first to work from this method, using the face as the unit, while Albrecht Dürer was the first to use the whole head as a unit. The French anatomist Paul Richer laid down the general rule that the body is equal to seven and a half head-lengths, but it's also possible to draw it in eight units, as illustrated here.

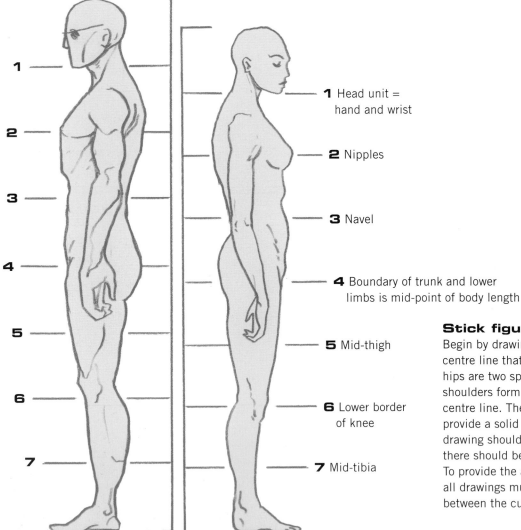

1 Head unit =
hand and wrist

2 Nipples

3 Navel

4 Boundary of trunk and lower
limbs is mid-point of body length

5 Mid-thigh

6 Lower border
of knee

7 Mid-tibia

Stick figures

Begin by drawing stick figures, starting with the centre line that runs from neck to navel. The hips are two spheres on either side, and the shoulders form a cross shape at the top of the centre line. The legs fan out at their bottoms to provide a solid base for the feet. At this stage the drawing should be loose and asymmetrical, and there should be no straight lines – just curves. To provide the all-important sense of flow that all drawings must have, aim for a feel of balance between the curves of the body and the legs.

Basic musculature

Bones are moved by muscles, which come in various shapes and sizes. As a rule, long muscles are located in the limbs and broad muscles move the trunk. Begin by copying or tracing the figure on the left; then, using a lightbox or tracing paper, copy the head and start developing the fantasy version of the same figure on the right. The fantasy version has the same head size, but everything else is exaggerated, and there are more muscles, which are much bigger and much more stylized. The drawing is made up of a series of curves that roughly follow the lines of the muscles.

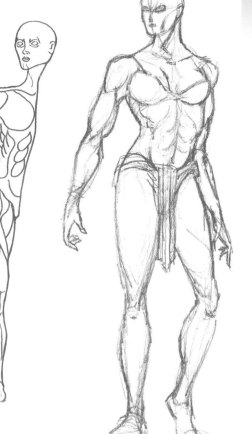

For a female figure, trace the basic male musculature but make the following changes as you go: make the waist slimmer and the hips wider; make the neck slightly longer; smooth out the muscles a little; and make the hands slightly longer and the fingers finer. Now use this figure as a basis for an exaggerated fantasy version. When it comes to the ribs, don't add one at a time: begin with the overall shape, then suggest the form of the rest if it is appropriate to the drawing – a fat figure will not show many ribs!

Work fast and build up lots of lines; let the pencil do the work. These rough lines help you to define the shape and weight of the figure. Don't be afraid to make mistakes, just keep building up the lines and gradually you will find the right shape – you can erase unwanted lines later.

Photography can be used in digital illustration to develop a knowledge of anatomy.
Ajanel by Bob Hobbs

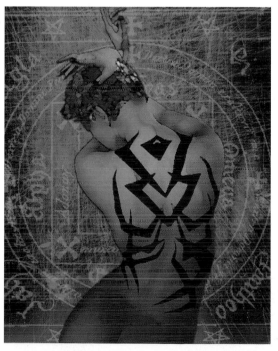

Details

It is important to develop your own set of lines and flourishes. As this is fantasy art, you don't have to stick too closely to what is anatomically correct, although it is good to have a sound understanding of the basic principles of anatomy. Once you have mastered basic proportion, you can begin to attempt a more fluid approach, allowing yourself more expression in the way you render your figures. You may wish to develop a loose approach, as here, or to be strict and detailed – it's up to you.

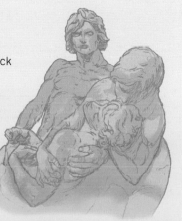

Faces

Faces are a lot of fun to do, but before you get into the details of creating amazing characters you will need to work out the mechanics of drawing faces; then you will have something to hang your ideas on.

When you start work on these exercises, don't aim to end up with a pretty picture. Be prepared to keep crafting the different elements of a face until you've almost obliterated it with pencil lines. If by chance you arrive at something good, you can always trace it off with a clean line. Whatever the case, be prepared to make mistakes – lots of them!

Front views

1 Start with a centre line, then add a circle for the back of the skull and hang the jaw on that.

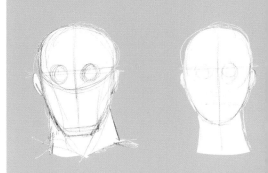

Profiles

1 Begin with an oval shape for the skull. Hang a jaw on the front and draw a line across from the forehead to the ear; then put in a circle for the eyes and a rough indication of the cheekbone.

2 Add some of the details. The male brow is heavier and juts out, while the female brow is a long slender curve right into the nose.

3 Work into the lines, noting how the eyelids are wrapped around the eye circles. Keep going over the same lines with soft lines at first then harder lines afterwards. With the male use short strokes with a bit of variation, and for the female use long single curves to denote the shapes.

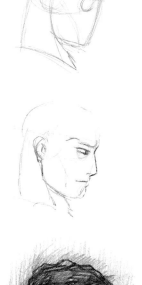

2 Add the pupils before adding the eyelids; it's easier to position them that way. Note that the male neck starts from just beneath the ears but the female neck is more slender. Add a line for the mouth, then sketch a rough shape for the nose; the female can have a small circle where the male can be a bolder triangle.

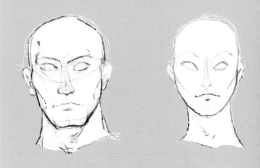

3 Now work into the lines as before. Try adding a thick line around the outside. Add shadows in the ears and eye sockets, and especially underneath the jaw.

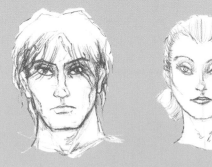

Three-quarter views

1 When adding the eye line, imagine you are drawing around a sphere, Placing the vertical centre line is all-important with the three-quarter view, as it helps to guide everything else.

2 Add the mouth line, cutting across the centre line. Then add the nose shape sticking out from the centre line. This is very tricky, so if at first you don't succeed – trace it!

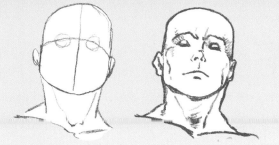

Face types

Now let's try some variations. On the portly face, right, the neck is very short and the face shape has less definition than usual.

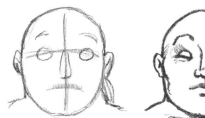

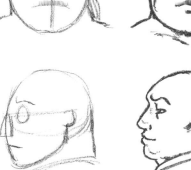

Angles

When looking up at a figure, the eye line is drawn as an upward curve, the jaw line is flattened and the ears are dropped down the sides of the head.

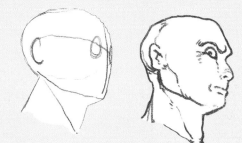

This angle might suit a crazed tyrant.

In contrast, the Gothic type is all sharp lines and angles, shown in the arched eyebrows and thin white lips.

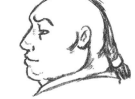

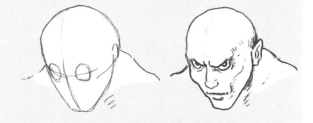

When looking down on a face, the eye line is drawn as a downward curve. This kind of pose is good for skulking orcs.

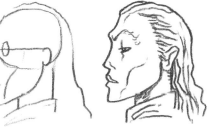

Note how curved the female's eyelids are as we look down on her; she looks pensive rather than alert.

Jaw types

A square-jawed female is going to look strong. This kind of face shape suits tied-back hair and full lips.

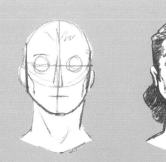

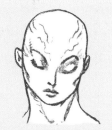

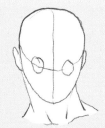

Neck angles

Try drawing the same face with different neck angles; this will affect the general expression of the figure.

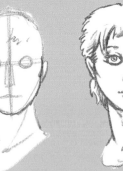

An oval-jawed female is more likely to have rosebud lips and a dainty nose, which you wouldn't put on a square-jawed face. A short crop might suit this type to achieve the 'pixie' look.

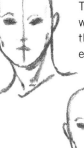

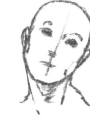

Expressions and features

Every artist develops personal methods for drawing eyes, ears, noses and mouths, and this spread shows a few basic methods to help you get started. You will soon see that the tiniest twist of a mouth, eyebrow or eyelid affects the way your characters look, so if you are having problems, trace these drawings first before trying again freehand.

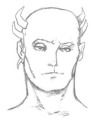

Expressions

Experiment with asymmetrical eyebrows: these are different on each side and can produce a variety of quizzical or whimsical expressions. Low eyelids can make a character look dozy.

Now trace off the original and try changing the expression. Downward-sloping eyelids and eyebrows result in a look of anger or tension. Follow the eyebrows up and around to create frown lines on the forehead.

Trace off again, but this time extend the jaw to allow for the open mouth. When a mouth is open, the upper lip is stretched so it becomes thinner.

Your average fantasy hero is not often seen laughing, but you can narrow the eyes and add laugh lines at the edges of the eyes and around the mouth.

Tilt the mouth to one side and add a small tick at the side. Make one eyebrow a frown and the other arched to produce a bemused look.

A smaller mouth looks bunched up; emphasize this by increasing the size of the lower lip and making it curly, resulting in a pouty expression. Pupils directed sideways suggest that the character is thinking.

Drawing a mouth

1 Always start with a single line, which can be straight or bow-shaped, as here.

2 Add the upper lip curving outwards to the Cupid's bow and the lower lip as a graceful curve. Add ticks at either end of the mouth line to give more character and a faint smile.

3 Lips need not be shaded as shown here, but it's always good to add a shadow under the lower lip.

Mouth types

The upper lip curves inwards instead of outwards to produce a more enhanced Cupid's bow effect. This kind of mouth is typical on fairies and elfin types.

A wide, generous upper lip and a thick lower lip with a bow shape are typical of queens and priestesses.

A curve at one end with a floating tick produces a wry smile.

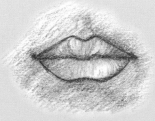

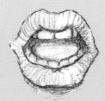

Try a more detailed version of the classic mouth shape, adding vertical lines curving outwards from the centre line to add depth. Work backwards and forwards over the centre line to make it darker.

Open mouths are notoriously difficult and do little to flatter. Drawing each tooth can be ugly, though it seems to work here. Try drawing the teeth as a single block and adding shadow underneath it.

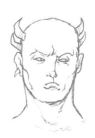

Mouth in profile

1 Draw a single line first.

2 Add the upper and lower lip shapes emerging out of the line of the face.

3 Then add the upper lip. The lower lip is a matter of choice; try both with and without it.

Nose

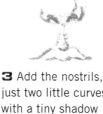

1 When drawing a face, put the mouth line in first and then put the curves of the nose with a quick circle at the end.

2 Add the outer lines of the two nostrils on either side of the circle; do these lines lightly, as you'll erase them later. These lines will decide the exact look of the nose. you can make them broader or more angular or higher than shown here.

3 Add the nostrils, just two little curves with a tiny shadow inside; these ones are fairly horizontal. Then add a darker line of the nose on the right hand side.

Ears

Every artist will have his own method of drawing ears, I learned mine from the Tintin books by Hergé. Grab a collection of comics and art books and go through them quickly, just looking at the ears and nothing else; you might be surprised at what you see.

1 For a quick result, first draw the outer line of the ear.

2 Add the top inside line.

3 Add another inside line at an angle to the first line.

4 Add a quick squiggle then put shadow around and especially under the ear

Female eyes

1 Start with two large circles and place the pupils.

2 Add the lids, making them wrap around the circles. Start from the outside and draw the top line first, giving it a slight slant. Then add the bottom line, again starting from the outside. Don't forget to include the shape of the tear duct. The positioning of the lines in relation to the pupils is not perfect at this stage.

3 To emphasize the eyes' shape, start from the inside and follow the curve out, then sweep away to form eyelashes. Go over the line a few times to build up. Then add the upper eyelid drawing from the inside, just above the tear ducts. Begin with soft lines that create shadow and then go through the dark areas with hard lines to increase definition. Add shadow above the eyes, drawing outwards to emphasize the shape of the eye sockets. Add highlights to the pupils with an eraser or white paint, or leave clear dots when you fill in.

Male eyes

1 The same rules apply as for female eyes, except that the eyes are less slanted.

2 You can make the brows a bit heavier than for the female. Define the lines as you did before.

3 Keep working around the eyes as you did with the female. With the male you can emphasize underneath the lower eyelid as well.

4 For older characters you can add more lines around the eyes by following through from the existing shapes. The lines on the forehead are a natural extension of the brows, curving up and around back on themselves. The eyebrows are lighter to denote grey hair.

Action

Fantasy heroes tend to have more muscles than normal people, which is baffling. Perhaps they need those extra muscles to vanquish the powers of darkness that are forever ravaging their kingdoms and threatening their princesses.

Just how much you stylize your figures is a matter of personal choice, but it's important to learn how to draw realistic figures – you have to know the rules before you can break them.

Drawing your figures as stick men can be a good way of working out various poses. Try doing several in quick succession to get your ideas flowing and your pencil moving.

Using perspective lines

A good technique for learning to draw figures in action is to use perspective lines to guide you (see pages 92–5). You may begin by trying to be very accurate, but as you gain confidence you will have less need for precision. Drawing bodies in action can be as much a matter of instinct as accuracy: sometimes a drawing looks 'right' without being perfectly accurate, and artists use tone, shadow, line work and colour to 'cheat' perspective.

1 Imagine the torso as a box, then put a twist on it. The centre line helps to guide this.

Figures in contact

The perspective lines here give the feeling of a three-dimensional space. A leg has been drawn in to define the centre of gravity; this roots the figure to the ground and helps define the twist of the torso.

2 Add arms and legs. This will probably take several attempts as you try out different positions.

Always draw your figures with a series of curved lines; learn to sculpt the shapes of the bodies, working over the lines several times to build them up and strengthen them.

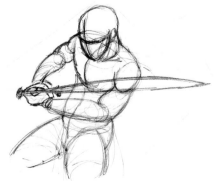

3 Use the perspective lines to help you define the sword.

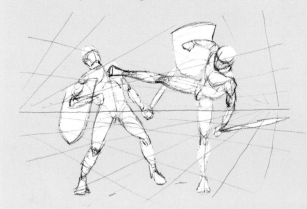

Cropping

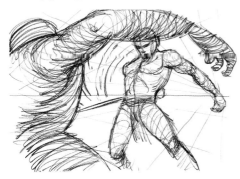 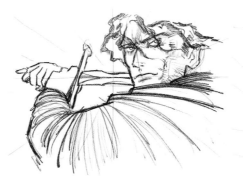

You can save yourself a lot of trouble by cropping in on figures so you don't have to draw the whole scene. In this case the focus is on the sweep of the sword. The foreground figure is reduced to silhouette.

The perspective lines here help to give form to the shoulder and the arm.

A worm's eye view, seen from below, enhances the impact of the figure. The main horizontal, known as the 'horizon' line, is low in the picture, so we are looking up at the figure. The perspective lines help to create foreshortening on the outstretched arm.

Adding the detail of the clothes and weapons is easier once you have defined the figures.

Flow

Work rapidly, and use lots of curved pencil strokes to give your characters volume. Try to capture the flow of energy in their movement.

If getting your anatomy precise is frustrating, try drawing manbeasts instead. This highly stylized figure did not need to have accurate human anatomy.

Compositions involving several figures can be very tricky. The bending figure was drawn first, his back being defined by the centre perspective line. The other figures were then built around him.

 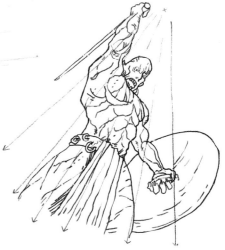

This image captures a figure in full movement, with special attention paid to a detailed study of musculature.

Asmodeus by Bob Hobbs

The need to make the figure express itself through body language and to give a sense of movement are both fundamental requirements, so the technique for breathing life into a figure is much the same.

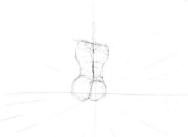

1 Start with a few perspective lines to which you add a centre line to give an overall impression of the 'flow of energy'. Add two spheres as the bottom of the torso: these define the buttocks and guide the shape and positioning of the legs.

2 Position the arms to define equilibrium and balance.

3 Then flesh out the figure using rapid, curving pencil strokes. Spiralling lines help define the volume of the limbs and torso.

4 You can see here how details, such as the hang of the clothes and the shape of the swords, have been guided by the original perspective lines.

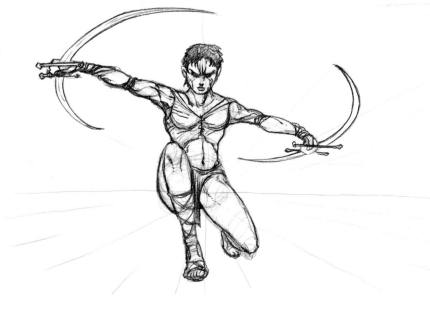

Extreme foreshortening

For this low shot of a leg kick, the torso is twisting away, so the nearer buttock is higher than the further one.

This kind of foreshortening is hard. Be bold! Find the form of the figure by using spiralling motions with your pencil.

Use your video or DVD on pause to find exciting action poses. You don't have to limit yourself to films in the fantasy genre; this pose is taken from *The Matrix*.

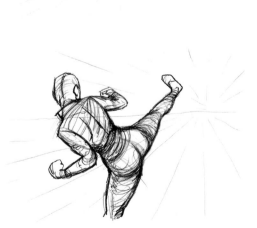

The centre of gravity is the point around which the body weight is distributed. The parts of the body supported in the centre of gravity mutually equilibrate each other like the arms of a scale or balance. The centre of gravity moves towards the floor along a straight line called the 'line of gravity'.

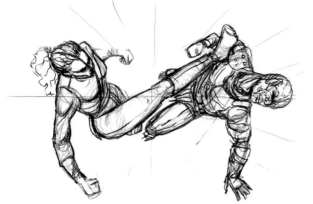

This high shot uses the perspective lines to define the tilt on the two figures. The main horizontal line helped with the twisting torsos of both bodies, and the perspective lines helped with the awkward foreshortening.

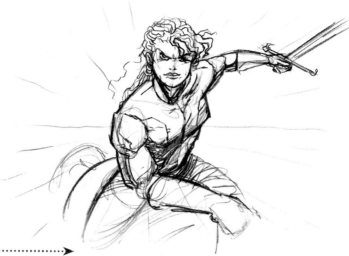

Very little of the torso is visible when viewed from this high angle. Most of the attention is given to the arms and the figure's right thigh.

The foreshortening is less extreme in this drawing, but you can see how it applies to the foremost arm; note how the rear arm is much smaller by comparison. Always pay special attention to the 'drop' of the shoulders – this affects the twisting of the torso.

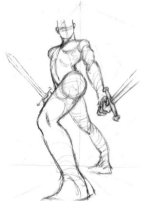

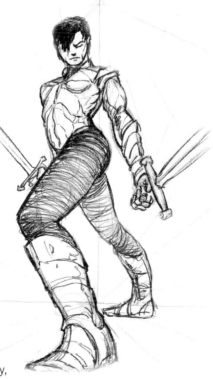

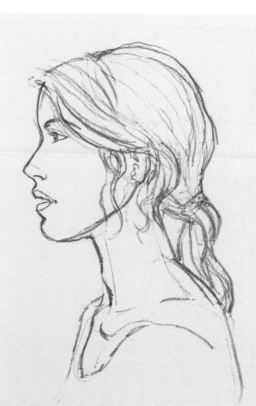

A low shot always causes problems drawing the leading leg, which gets larger as it comes towards us. Getting details like this right is a matter of trial and error.

The head is facing directly towards us and is therefore looking down. By drawing it this way, you can avoid drawing it from a difficult angle.

Life drawing

Many artists enrol in life-drawing classes throughout their careers to refresh their skills. Quick sketches of situations seen in everyday life can also contribute to your understanding of anatomy.

Zuhatz, August 2001 by Finlay

Hands

Hands deserve a lot of attention because they are almost as expressive as faces, and you need to master them in order to produce convincing images. A lot of people confess to having great difficulty drawing hands – they are invariably small and fiddly compared to the overall size of a figure, and finding the right shapes can be infuriating. Fortunately most of us own a pair, so research isn't a problem: just set up a hand mirror on your desk and practise that way.

The bones of the hand are complex and small so the hand can move through a very wide variety of motions; this flexibility is what makes hands difficult to draw.

Note that the fingers taper towards the end but thicken slightly at the knuckles.

The visible tendons passing through the wrist.

Look at your own hands to get the relative proportions right.

You can then begin to stylize – here I've added metal tattoos in the style of computer circuitry.

Fist

1 Try breaking the hand down into blocks first, to define the general shapes.

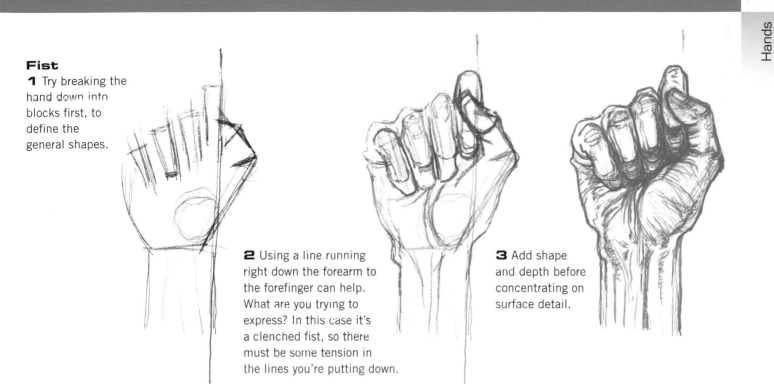

2 Using a line running right down the forearm to the forefinger can help. What are you trying to express? In this case it's a clenched fist, so there must be some tension in the lines you're putting down.

3 Add shape and depth before concentrating on surface detail.

Using hands

Here are a few examples of using hands in fantasy images. In each image the hands are doing something or appearing in an out-of-the-ordinary context. Have a look at the images here, then see if you can come up with some weird scenarios for the hands you have drawn. Think about how the hands are used to express different feelings in different images; think about the messages they convey and ask yourself the same question – what can I make these hands say? Are they caring, angry, protective, greedy, shy or friendly? Put them in a situation that reflects that, or try putting them in a situation completely the opposite to what they are expressing.

It's always great to work for a band you love, and I love Muse ... so I jumped at the opportunity to produce images for their single 'Hysteria'. It's a song about intense desire, so we played around with ideas that expressed that emotion. In the end two sleeves were released, both featuring hands that were demanding and desiring but in very different ways: in one version soft, fluid hand shadows caress a female body, while in the other a threatening crowd of hands is reaching for the moon.

Muse images: Storm Thorgerson, Dan Abbot, Rupert Trumon and Lee Baker.

This was a design for a web animation celebrating the 25th anniversary of Pink Floyd's *Wish you Were Here*. The landscape of withered hand trees seemed to express a need to reach out, a desperation for human contact, which we felt reflected the tone of the songs.

This was an idea for the rock group the Cranberries. There is an obvious reference to the 'hand of God', but it was more about dreams and the powerful influence they can exert on us.

Character

The process of turning your male and female figures into heroes and heroines can be endlessly entertaining and absorbing. This is the area where you can let your imagination fly and begin to breathe life into your characters, as you explore their costume, style and personalities, and make important decisions about their image and outlook.

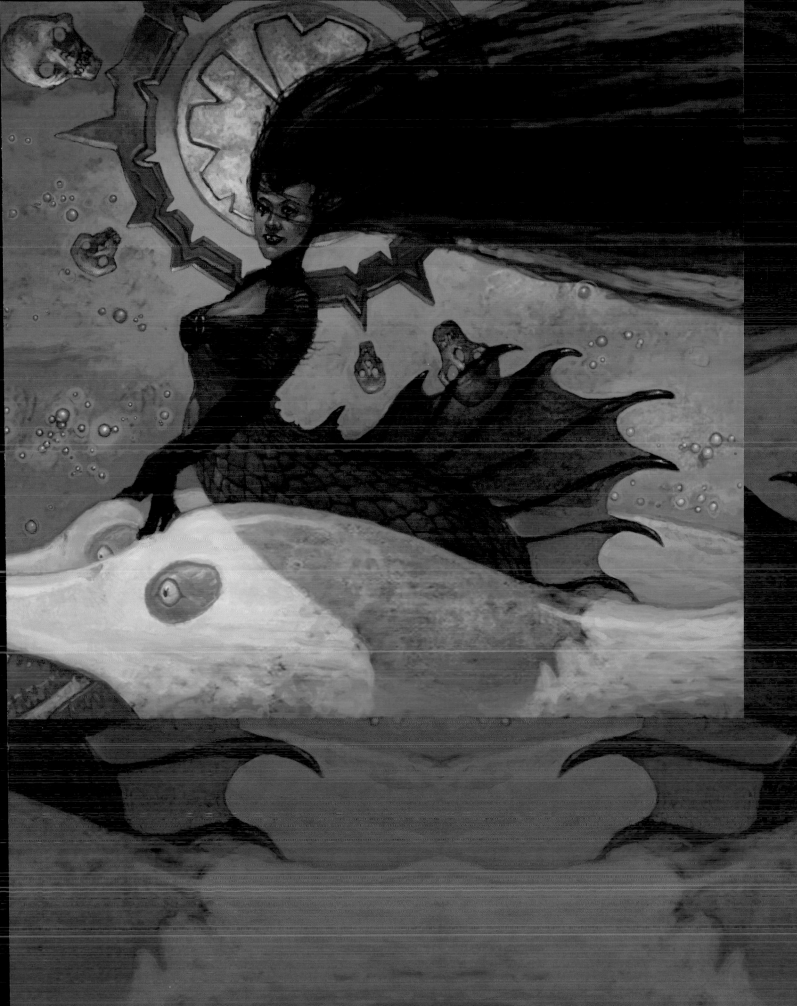

Male archetypes

Male characters come in all shapes and sizes, but most heroes fit into a few classic categories known as archetypes. The word 'hero' is given a loose definition here, and means a character who guides us through a story, someone on to whom we can project ourselves. For that reason villains are included as they often fulfil a similar role: a guide through the world of myth and a figure with whom we can emotionally identify in some way. All the characters here could be good or evil – it's so hard to tell the difference these days – and your hero can be one of the following or a mixture of the qualities of several of them.

Warrior hero
The classic hero has his origins in characters such as Heracles or Odysseus from Greek myths: a warrior and an adventurer. In modern times he is the kind of character most often played by Vin Diesel or Tom Cruise; a hero who has few moral doubts or uncertainties and can be easily identified as the good guy by the audience. This is the character who will always win the hand of the princess or set out on the quest for the golden hoard.

Antihero
This character is most likely to be a loner or a wanderer. He is appealing because there is often something dark about him; he is an outsider and his true motives are often ambiguous, Clint Eastwood is often cast in this role, and the character of Aragorn in *The Lord of the Rings* is clearly a loner and an outsider.

Choose a simple colour scheme for each character, which helps to define them better. Imagine a 'trademark' skill, power or weapon that is individual to the character – in this case two curved swords with distinctive hilts.

Boy hero

This archetype is the one most likely to be found throwing rings into volcanoes because he is essentially pure of heart – and this can be reflected in his body language and expression. His greatest strength is his innocence, which is a fundamental part of his appeal.

King

The king is a hero with enormous power and responsibility. It is not his place to wander off in search of gold or follow his own star: he is entirely responsible for the well-being of an entire nation, and he can wield enormous power in its name. He is a living symbol, and when he acts, he does so on behalf of his land and its people.

Wise man or magus

This character is a mix of the antihero and the king. He has the freedom of the antihero, but the wisdom of the king. He has transcended the needs of the hero and has an outsider's perspective, so he can always see the bigger picture.

Comedy hero

A classic character who plays off the hero to help create a lighter side to a story, this figure allows the hero to speak his mind and provides a forum for discussion. He often acts as the hero's conscience, reminding him of his principles and bringing him down to earth when he forgets himself. This character can be based on Shakespeare's classic creation, Sir John Falstaff.

Female archetypes

Female archetypes are as varied and interesting as their male counterparts. Ancient myths contain a myriad of female figures, who vary a great deal in their position in society. For instance, in *The Arabian Nights*, a sprawling work collated over a period of 1,000 years in the Middle East, there are many female characters who are more cunning, clever and courageous than their male counterparts; however, in Greek myths it is shocking to find what cruel treatment this ancient civilization thought up for its female deities.

Queen/princess/goddess

This type is likely to be elegant; note her flowing robes and the haughty positioning of her head, held back and aloft. Pay special attention to detail: this character wouldn't be found wearing heavy, clumsy jewellery – it is always delicate and ornate – and similarly, her hair may be long and flowing, but never wild or unkempt. (Costume design, Marlene Stewart.)

Witch queen

This character type is appealing because she is evil but beautiful. In this example her manic stare was produced by emphasizing the whites of her eyes. Her haughty disposition was evoked by the low angle of the drawing and details such as her arched eyebrows and beauty spot, and by the rigid symmetry of her posture.

Young heroine

This character is kitted out for travel and her boots and clothes are well worn – this gives the impression that she's been swept along by events beyond her control. Her intrepid stance and serious expression show that she has learned to survive by cunning and wit in the absence of magic or physical powers.

Inspiration: the goddess myth

The goddess is a terrifying and protean deity who has a place in every religion and demonology. To the Sumerians thousands of years ago she was Inanna, who gave way to Ishtar of the Babylonians and in turn became Astarte of the Phoenicians and Aphrodite in Greece. The Philistines called her Atargatis, and in India Kali represents the ultimate reconciliation of opposites: death and creation. In Italy, wise Sibilla gave her name to a mountain range, the Sibillini.

Warrior princess

A warrior is obviously a fighter, so she'll need to have a highly developed musculature. Her stance is confident, and her feet are planted firmly on the ground. For a warrior, consider an earthy, practical colour scheme that would work as camouflage.

The goddess

Whatever her incarnation, the presence of the goddess is felt in whatever makes the hair rise or the heart leap. The goddess figure in mythology is the mother of all living things, the ancient power of both fear and lust – the female spider or queen bee, whose embrace is both life and death.

Developing character

Now you can begin to work on character development – the process of refining and defining the look and particular qualities of your character. Start by aiming to cover several large sheets of paper with sketches and drawings of the same character: drawing the same character over and over can be quite difficult at first, but after a while you should begin to find a specific set of visual 'ticks' that define that particular character accurately.

Human diversity

It is impossible to generalize about ethnic variations, but in the highly stylized world of fantasy design, basic differences in characteristics can be a good source of ideas for character development.

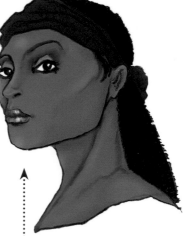

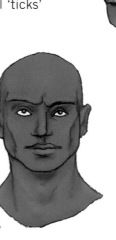

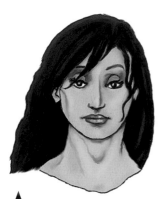
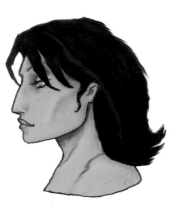

An Afro-Caribbean female can be given a broad nose and large lips. Heavy eyelids and large, dark eyes can enhance the look.

An Afro-Caribbean male can have a broad nose and large lips that tend to be slightly paler in colouring than the skin, which can range from dark cream to almost black. Eyes are almost always dark brown.

People of Middle Eastern origin can have sandy, almost golden, skin colouring. A large, curved nose can give this type a powerful presence, and large, heavily rimmed eyes are attractive on any facial type.

In profile, the nose of the Middle Eastern type can be drawn as a single elegant curve with little variation in its arc.

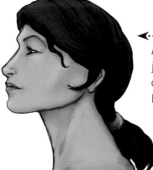

A long nose and prominent jaw make for a proud look, often seen in people of Hispanic origin.

In comparison, the nose of this more Asian type is also large but has a nib at the end. The skin colouring is dark and reddish, and the hair can be a deep glossy black. The upper lip can have a strong upward curl.

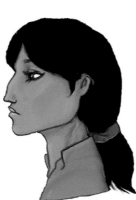

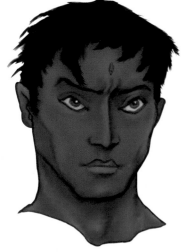

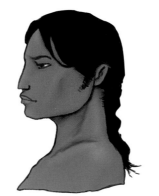

An Asian male can be given similar characteristics, such as a long nose with a prominent hook at the end. The lips can be pale and fully formed, almost feminine in shape. Note as well the large, heavily rimmed eyes, which have a definite slant.

South American people and native Americans can be given a nose that lies close to the face. Also note the way the upper lip curves outwards rather than inwards.

Character development sheets

Work up some development sheets for your characters, making notes about what you think works and what doesn't. Try minor adjustments on successive sketches, such as changing the curve and length of the eyebrows or adjusting the type of nose. Don't erase anything – you need to be able to look back and see how your character has developed.

The classic Western profile, as seen on Greek vases, has a long nose that lies close to the face and doesn't dip very much at the brow. This type is the most likely to have red hair complemented by green eyes.

A typical Caucasian or Western male can be given a straight nose and a large mouth. The eyes are more likely to be smaller than the other types and are likely to be blue, green or brown.

Women of the Far East can be given heavy-lidded and slanted eyes. Note in particular how the chin doesn't jut out at all but curves directly back from the lower lip.

Scandinavian and German males are renowned for having well-defined jawlines and cheekbones. Skin and hair is often pale.

The male counterpart can also be given slanting eyes, and a small button nose can also work well on this type.

For a Burmese look, try setting the eyes wider apart and making them long and narrow. Note that the nostrils are also quite wide apart and that the mouth is extremely full in proportion to the other features.

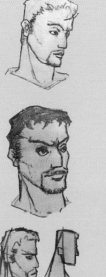
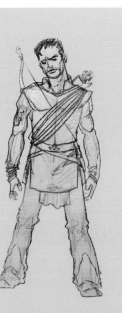
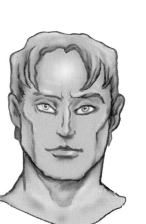
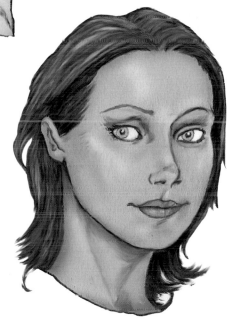
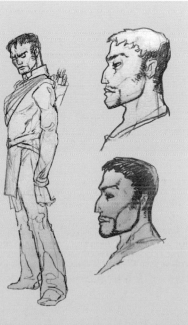

Eastern European and Scandinavian females can be given high cheekbones and short, turned-up noses. Eye colouring can vary but is most commonly blue, grey or green. The eyes can be made to slant very slightly, a look that becomes more pronounced the further east you go.

Clothes

It is the subtle differences in clothes, armour, hair and accessories that make the art of styling so important in fantasy art. Costume designers and stylists are particularly valued for their skills in the film industry, where the image of each character can have a massive influence on the credibility of the film with audiences worldwide.

Cloaks

Here's an easy technique for getting the shape of a cloak right.

1 On a basic figure, first draw the two outer lines of the cloak.

2 Next, draw the bottom line, curving in and out.

3 Draw the lines of the folds upwards from the bottom line.

Dresses

Dresses work on the same principle as cloaks: you have to wrap the fabric across the body and follow the lines of the body as you go. Do this with a lot of rough lines then refine the drawing afterwards, selecting the best lines for a clean version.

In this image the artist has developed a specific style of detailing on the clothing, which remains consistent throughout. The detailing on the gloves, boots and belts has a similar style of execution, which gives the character a clearly identifiable look.
Lazer by Bob Hobbs

Tribal clothing

History and cultures from around the world are the best sources of ideas for outlandish costumes: the examples here come from the world of reality, and need little work to make them perfect for fantasy characters.

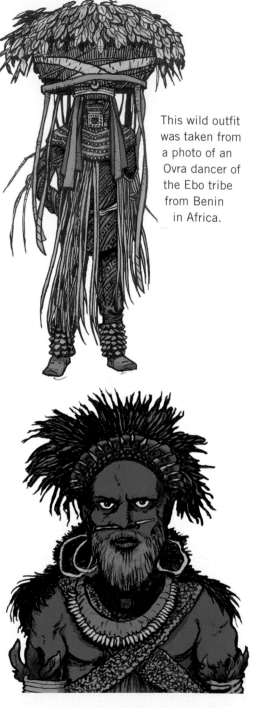

This wild outfit was taken from a photo of an Ovra dancer of the Ebo tribe from Benin in Africa.

Precise details for elaborate costume and jewellery can be developed effectively by looking at imagery of fashion and culture from around the world. This drawing was taken from a photo of a tribesman in Papua New Guinea.

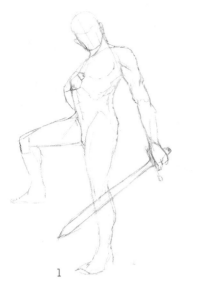

1

2

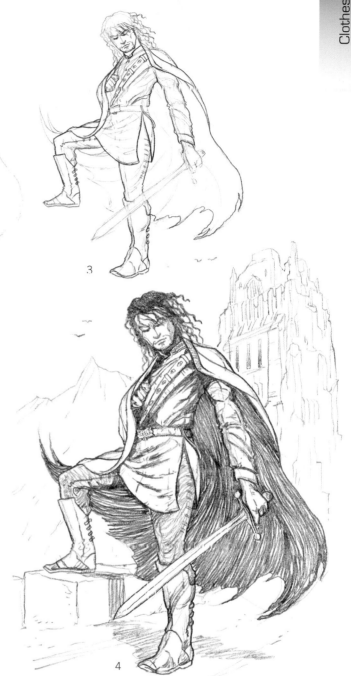

3

Clothing a figure

Whether skin-tight or loose and baggy, clothing must relate to the anatomy of the figure it covers (see page 18); this exercise starts with the body and builds the clothing on top.

1 You must decide first what your character will be so you can draw the pose accordingly. In this case, a noble warrior is standing on the castle battlements.

2 Draw a series of lines that appear to wrap around the body; these can go around the cylinders of the arms and legs, but it is best to work diagonally across the body shapes. The billowing cloak also seems to follow the energy lines of the body: start from the neck and sweep outwards from there before exploring the curves as it whips around the legs.

3 Use the rough lines to guide you in adding some detail. Note that the clothes all crease at the joints and are drawn on the outside of the body lines; seams and small details such as laces also follow the lines of the body. The hair blows in the wind in the same general direction as the cloak.

4 Add the shadows, which have to appear under every fold and line. Note the shadow of the sword appearing on the boot and the shadow of the figure on the ground. The background was added as a loose sketch.

4

Celtic ornament

Fantasy art tends to use Celtic and Norse design as one of its main sources for ornamentation, although it's important not to limit yourself (for example, try looking at Aztec and Mayan art). Celtic knotwork is based on a mathematical set of rules that are hard to learn but easy to master; the grids for hundreds of patterns can be found easily in books or on the Internet.

1 Draw or trace this grid of evenly spaced dots and draw the lines as shown.

2 Now imagine the lines are much fatter and draw the spaces in between.

3 The trick here is to decide which lines overlap and which underlap – that's the secret of Celtic knotwork. This is one version, but you could produce dozens of variations based on the same grid.

4 Designs of this sort can be applied to various treatments: they can feature as metalwork on belt buckles and sword blades, as leather tooling on clothes and book covers, or embroidered on flags and standards.

Armour

Most armour in fantasy art is loosely based on European medieval armour, with a few minor differences for the sake of practicality. For example, full breastplates and back plates are usually avoided in the film industry, as they hamper mobility during action.

1 Make sure that the pose of your characters reflects the fact that they are carrying a lot of weight – they should appear firmly rooted.

2 Armour can be 'wrapped' around the body and divided into various protective and decorative elements.

- **Open-faced helmet in the style of an Italian 'barbute'**
- **Neck protection: 'gorget'**
- **Overlapping shoulder plates: 'pauldrons'**
- **Articulating rivets where plates meet**
- **Elbow protection at joints**
- **Heavy edges on plate armour: 'turner'**
- **Straps to hold chest and thigh plates**
- **Flexible metal shoes: 'sabatons'**

3 This is where the 'fantasy' part comes in, as detail is added to each element of armour.

- **Helmet: embossed decoration**
- **Gauntlet: additional plates**
- **Breastplate: decorative engraving**
- **Thighs: fluted, layered plates**
- **Knees and calves: extra wings and spikes added at joints and legs**

4 Here, shadow is laid on to the extent that the armour appears to be black. Use smooth, hard lines, beginning with the shadow areas and working out on to the surfaces.

Shadows on armour

1 Outline the basic plates of the armour.

2 Add the basic shadows, using curved shapes to complement the curves of the armour. An 'outer' line makes the white space appear to be a highlight; light strokes give the impression of a reflective surface.

3 The illusion of a dent can be created by erasing a semicircle in the shadow and adding a shadow opposite. Add flecks and scratches to give the impression of ageing.

1 2 3

Armour variations

Armour need not just be based on historic styles; look to the natural world for interesting organic shapes.

This outfit, made entirely from sea shells, was inspired by pictures from old books. Such shells were used as armour by South Sea Islanders.

- **Horns wrapped around the arms**
- **A scallop for a shoulder protector**
- **A spiked nautilus shell for a helmet**

This outfit was inspired by a mixture of insects and sea life.

- **The gruesome skull of a wolf fish**
- **The thick bony carapace and serrated antlers of stag beetles**

Historical reference

Ancient armour, such as that worn by this Greek hoplite, provides a huge resource for armour and weaponry.

Hair, jewellery and accessories

The way you style your characters with the addition of distinctive hairstyles, jewellery, tattoos and piercings can help to define them, making them distinctive and original in their appearance. The main aim with these accessories is to give them the appearance of three-dimensional volume, which has the effect of providing them with 'weight' and 'body'.

Giving hair volume

Try this simple exercise to help understand how to give hair the appearance of volume.

1 Start with a basic head shape.

2 Draw a series of three-dimensional shapes laid around the head. Here, they are cylinders, but you can also use spheres or even cubes and pyramids.

3 Add more shapes to give the impression of long strings of objects.

4 Now you can use these shapes as a guide to draw a hairstyle, breaking up the original shapes as you draw over them. You can see from this example how doing this gives the impression of a luxuriant mane of hair and provides some idea of how the hair hangs.

Using references

Old books can be a great source of inspiration for character detail: this image was inspired by a six-volume set, *Peoples of the World*, published in the early 20th century.

Hair can also be drawn from a single point on the head called the crown. This gives an idea of the way the hair will hang on the skull. Note that there are shadows under the hair closest to the skull.

Looking for variations

Experiment with different hairstyles on the same face: the examples below and above right are based on the same face, but different hairstyles and accessories make them entirely different characters.

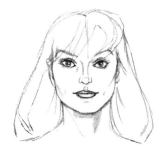

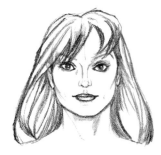

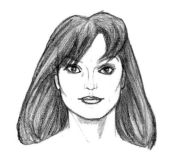

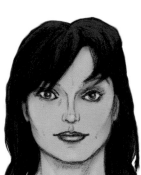

1 In the first exercise, begin by putting in the main shapes. Note that there is a side parting and an indication of the crown on top of the head.

2 Add more detail. Here, the hair sweeps out from behind the ears and behind the neck. Remember to add more shadow in these areas and around the hair line.

3 Keep working into the hair with more shadow, which is strongest around the face and neck. Also pay attention to the way the hair separates into a number of bunches.

4 Be prepared to make changes to the overall style of the hair. You can see from this example that the overall look of the face is changed by making minor adjustments.

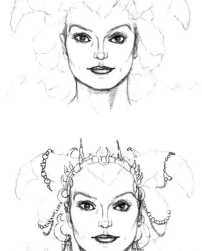

1 In the second exercise, you can see how a totally different hairstyle is applied to the same face. To start, add a series of shapes of hair to the head with a rough indication of the shapes' volume.

2 With this hairstyle, you can hang jewellery on the hair as well as from the ears and around the neck. On the hair, the items of jewellery appear to be draped over the objects; draw a rough guideline first and then draw each individual pearl with a slight overlap. This technique of overlapping objects applies to all the jewellery seen here.

3 Draw dark lines around every single object to give them strength, and while you are doing this, put little shadows underneath the objects. Next, add the shadow areas on the hair pieces: start with lines that follow the shapes and keep working over them. (Some of the detail will get lost as you add more shadow.) Be sure to pay special attention to where the objects meet the skull, adding lots of shadow and strengthening your lines by working over them several times.

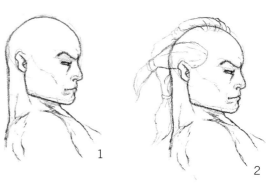

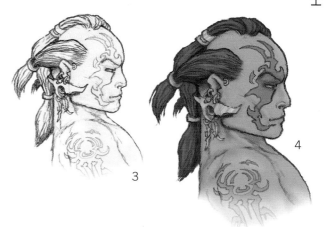

Male hair and markings

The character of this male warrior is given definition by his distinctive tattoos, jewellery and hairstyle.

1 Start with a bald head and ask yourself what kind of accessories you want to add. Will the character have two or three or four ponytails? Will he have long earrings or short ones?

2 Add some basic shapes – note how the hair on the top of his head crosses the skull line and the hair at the side appears to wrap around the skull as it goes to the back.

3 Work into the hair, making sure that the outer lines are strong and there are shadows close to the skull. Add jewellery by putting in rough shapes: start at the ear and then overlap them as you work downwards; you can erase the rough lines afterwards. The tattoos seem to follow the shape of the skull – this is a matter of trial and error, and you may have to try out a few different designs before finding something that works.

4 When working in colour, a similar principle is used to working in pencil: after applying a basic overall colour, the shadow areas are emphasized. Put shadow in the eye sockets, under the nose, under the lips, around the ears, along the hairline, under the jaw and so on. You can also add highlights above the cheekbone, along the nose and above the eyebrow.

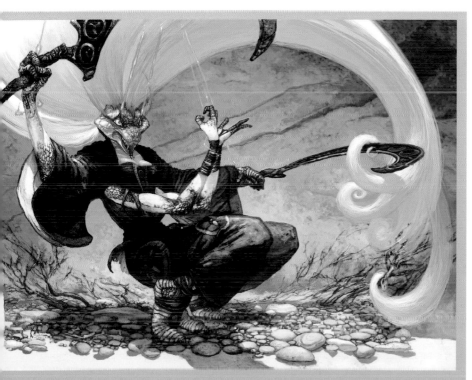

feature: Watercolours

When watercolours were first invented in the late 18th century, they were a revelation because they allowed artists to get out of their studios and do quick colour paintings on the move for the first time.

Equipment
A starter set of watercolours can be cheap to buy. This will help you to get started, and if you find you like the medium you can progress to more expensive materials. You will be amazed at the intense colour of some paints, such as Schminke.

Paper
HP (hot-pressed) and Rough watercolour papers have different textures and give the artist opportunities to create interesting blends and effects by messing around with water and paints. Paper prices start off very low, and it is advisable to buy lots of cheap paper to begin with so you can practise.

Brushes
Make sure you have at least one very thick brush for laying down large areas of water. How many finer brushes you use is a matter of personal choice, but it makes sense to have a couple of medium size (say, Nos 6–8) and a couple of fine ones (say, Nos 2–4) so you can change colours quickly. I aim to get by on the absolute minimum amount of equipment.

Watercolours are ideal for working very quickly. Rough watercolour paper is textured and may have rough edges.

Interesting textures and blends can be created by pooling water on the paper first then adding colour while the surface is still wet.

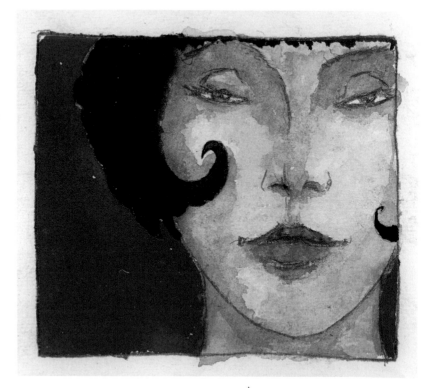

Watercolours are useful for working out colour schemes before committing to acrylic or digital painting. I used this sketch to work out the way in which the light fell on the face.

It is also possible to get strong, flat colours by mixing less water with the paint. The red background and black hair in this sketch contrast with the more subtle, lighter blends used on the face.

Watercolour and ink

1 You can use watercolours and inks together to develop a strong illustrative style. Begin with a pencil sketch on watercolour paper.

2 Use two or three colours together and mix them around on the page. Add more water to create lighter areas. You can see how 'tide marks' form when the colours dry – sometimes these can improve the picture, sometimes they work against it. If you add more water you can continue to blend these areas and make the effect more subtle.

3 You can then leave the colours to dry and then start again with fresh layers of colour. You have to be careful at this stage, because adding the wrong colours in the wrong way will result in a muddy image. The only solution to this problem is practice and experiment, so be prepared to make mistakes. The picture can be finished off by adding detail in black ink after the colours are completely dry; in this case it was executed with a cheap fountain pen, but brushes can be used as well. Such line work helps strengthen the image and covers up untidy edges left in the colouring process.

1

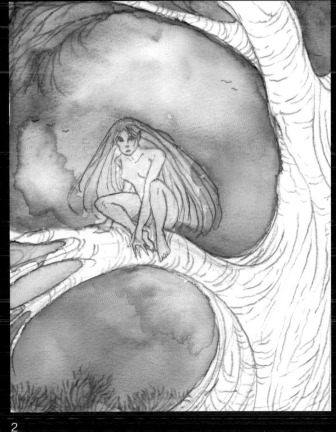

2

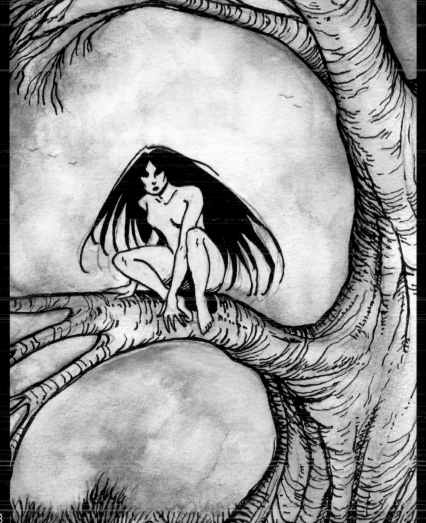

3

Wood goddess

When coming up with an idea for an image, it is sometimes best to have no idea where you are going or what message you want to convey.

I didn't know what the image of the wood goddess shown on these pages was supposed to mean – I just liked the idea of a woman with trees for legs. It was only as I worked on the idea that I began to understand what the image would signify. Remember, it's your fantasy world: you can do whatever you want, and the process itself can be a voyage of discovery.

Doodles

Begin by playing around with a few very rough sketches, and try different versions of the same idea to see which one seems the most exciting to you. All I could tell at this stage was that I liked the idea of both legs becoming a single trunk and the big circular shape behind her (bottom right).

First study

The woman in the first proper study for the painting has a calm expression, and her body language is relaxed. I also stumbled on the idea of some kind of machinery or clock behind her, at which point I started to get ideas about the meaning of the image. This woman represents the spirit of the woods, so she's a wood goddess, and the machinery behind her symbolizes industrialization and the ever-growing threat to the natural world.

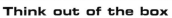

Think out of the box

I tried going off on a complete tangent and having the girl half lighthouse instead of half tree ... that's an idea I can come back to some other time.

Final study

If my wood goddess is being threatened by industry she should have a much more dynamic body language, not relaxed at all, so in this study I made her more powerful-looking. I wanted to make her look half terrified and half terrifying; you would think twice before cutting this tree down.

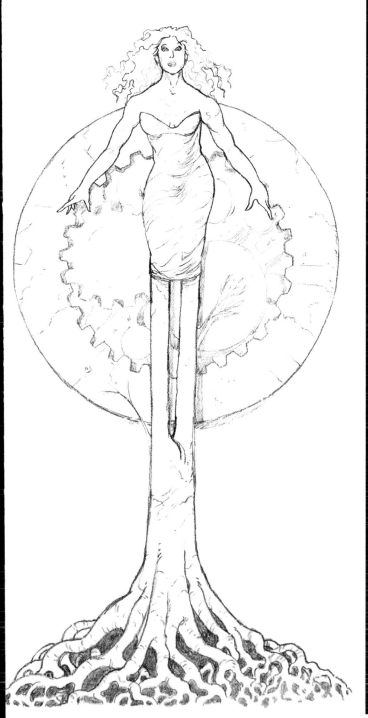

Colour tests

Even if you are going to do your final painting in oils or acrylic, watercolours are a quick and effective way of trying out different colour combinations. It is always good to take a few different approaches to a painting before you begin. The more times you try, the better it usually is.

Magic Carpet Ride 1 and 2 by Finlay

Once I had decided the meaning of the image I knew straight away what the colour scheme should be – woods always look so wonderful in the autumn, so I decided my goddess would have red hair and a red dress. When thinking of what a wood goddess's dress might look like, the immediate assumption would be to have some ethereal, floaty, diaphanous thing ... so I decided to give her a tight red evening dress instead, which has made her look a bit like Sarah Jessica Parker from *Sex in the City*, but what the heck – it's my fantasy world and I can do what I like; and the same goes for you, remember.

1 Begin by tracing off a simple line drawing on to light (190gsm/90lb) Bockingford watercolour paper and put in the basic colours. I stuck to a fairly narrow range of colours, which are very light here: I used more water and less paint, dipping the brush in water regularly as I went along and pushing the colours around the paper to create textures.

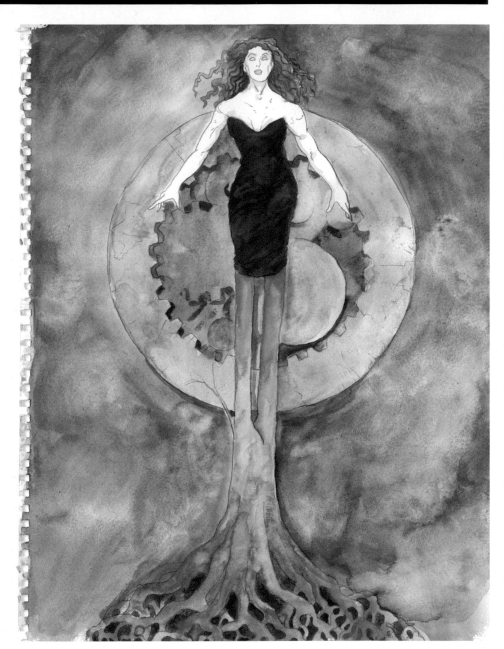

3 Begin to define detail and hard shadows by using less watery solutions. The thicker the paint the harder the line, so leave the very fine details until the final stages. I used a dark brown to outline the trees and worked into the dress and hair with oranges and purples with a very fine brush. Some of the lines stood out far too much, so I decreased their impact by going back over them with water and blending them a little. You can also add water and dab with tissue to erase mistakes and make interesting textures.
I put a very light wash of green-blue over the machinery because it was too similar in colour to the tree. At the very end I went over the figure with a strong pencil line (most artists would do this with black ink or paint, but I feel more comfortable using a soft pencil).

2 When the basic colours are dry, or nearly dry, add more layers of colour with a flat brush, starting at the lines and working away from them. The colour is always stronger on the first brush load so you can pull it across the page away from the lines much more easily than you can working up to the lines. If some of the patterns are too obvious, you can add more water to them and push the colours around until you are satisfied with the amount of blend.

I always work two colours together, usually those that are closely related, to get more interesting effects. However, you can use bright colours underneath dark colours to make the final blend 'shine' a bit, as I have done by putting yellow down on what will become a dark background. Keep working more layers of colour and detail in – the image may become muddy, but you will find that the more you work into an image, the better it becomes.

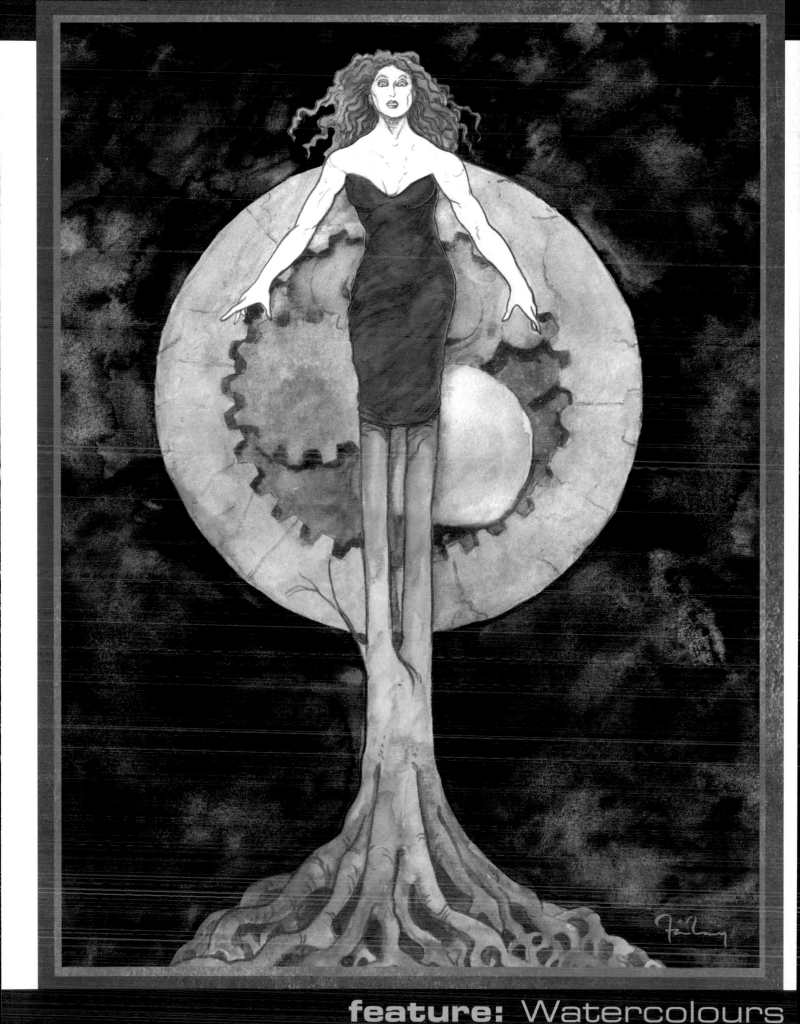

Creatures

If you are confounded by drawing human figures, it may be best to turn your attention to the semihuman species of your fantasy world. It is with these creatures that you can really let go: their anatomy does not have to be accurate, or even symmetrical, and their costume can vary enormously from figure to figure. It is here that you can experiment and let your pencil explore the form, shape and detail as you learn to develop your own style and techniques of rendering your figures.

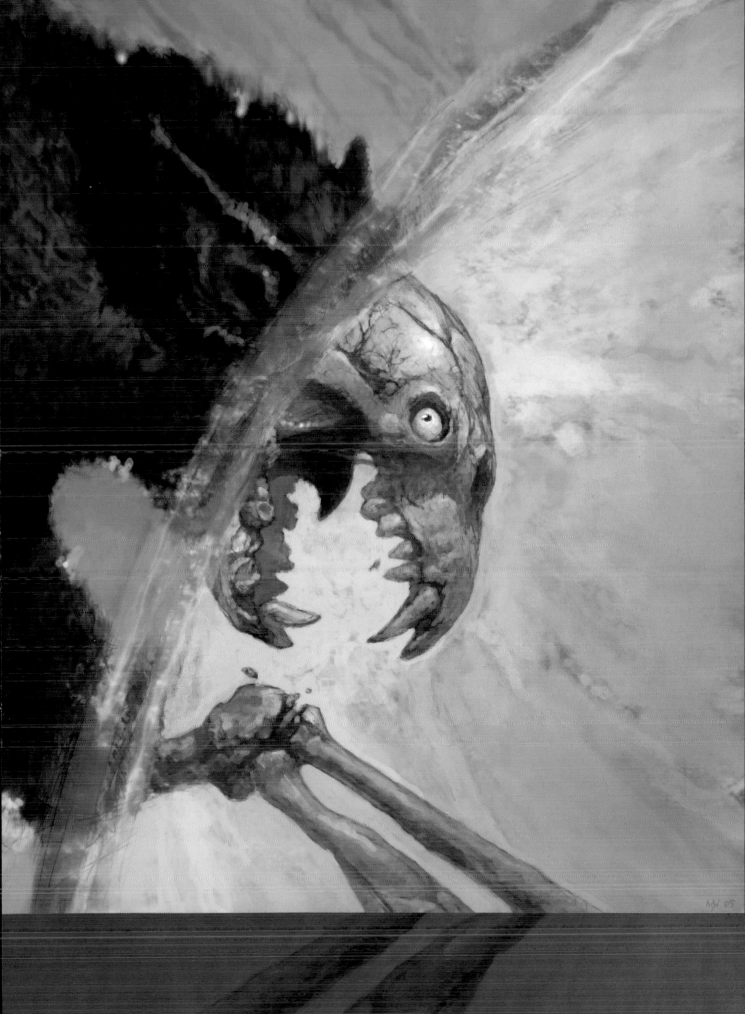

Manbeasts

Monsters and creatures can be fun to draw because they don't have to make sense. You don't have to worry about making them anatomically perfect and you don't have to worry about making their clothes perfectly symmetrical, so you can really let your imagination fly.

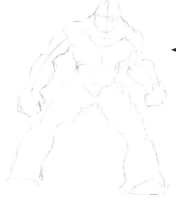

1 Start with a basic humanoid shape, but try exaggerating different features, such as the massive forearms and feet of this character.

2 Add detail and let your imagination run riot – gloves and other accessories don't have to match. In this case a lot of decaying scraps of cloth have been added – the average manbeast is not likely to have a great deal of fashion sense: you want to make your character look like it hasn't had a change of clothes for a long time.

3 After you've figured out roughly what the character is wearing, go over your drawing again, adding shadow and strengthening the shapes of each element of clothing. Sometimes it's good to work from one side of the drawing to the other to avoid smudging.

5 When the original line drawing is seen with the colour layer you can see how the whole drawing looks much tighter. Photoshop allows you to try a whole range of subtle effects and colour changes at the touch of a button, but it's best to keep these effects to a minimum and rely on the quality of your original drawing.

4 All the colour was added on a single layer in Photoshop. Note that colour variation is kept to a minimum; this is a good way of ensuring a consistent tonal range and applies to all methods of colouring. You can also see from this colour layer that every element is given a shadow and a highlight.

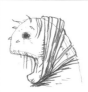

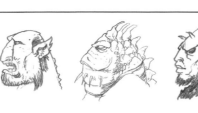

Experiment with exaggerated proportion and features: make heads extremely pointed or explore strange nose shapes. Add horns, tendrils, scales and fleshy protuberances.

From real to fantasy

These totems and fetishes were all drawn from real specimens in the Pitt Rivers Museum, Oxford, England. Ethnological collections can be a great source of gruesome accoutrements for your orcs, demons and denizens of the underworld.

The skull of a type of antelope inspired the horns for this strange demon.

This drawing of a horse's skull found in a natural history museum provided the inspiration for this 'ringwraith' type of manbeast.

A lion's skull provided the unlikely reference for this lizard warrior. The point is, the reference point is just a start; you can take it somewhere entirely different.

This creature seems to be a composite of elements; a burning, smoking skeleton clothed in flesh and curious metallic elements. With manbeasts, anything goes! *Chuffling Zombie* by Anthony S. Waters; © Hidden City Games, LLC. Reproduced under license

Female creatures

Fairies, water sprites, angels, valkyries – the world of myth is full of female creatures, each with her own peculiarities and folklore. You can get ideas for your characters from the endless supply of books about myth, or you can invent your own variations.

Finding inspiration

The early 20th-century illustrator Arthur Rackham has become the world's most collectable creator of fairies and other fantasy creatures. He is most famous for his illustrations for *Peter Pan*, and his versions of the characters have become the template for artists ever since. In this illustration I've tried to create my own version of the fairy Tinkerbell.

2 Strengthen the lines and consider small details that will enhance the character. The curl of the toes makes her appear dainty and fey.

1 Your fairy should have a light figure, slim and agile. Also take care to consider her body posture: in this case she has a relaxed and thoughtful stance – compare this to the assertive stance of a warrior female, and you can see the difference.

Rackham's fairy wings were usually inspired by butterflies or dragonflies. In this case, I used this picture of a flying ant because the lines on the wings vary but are easy to copy.

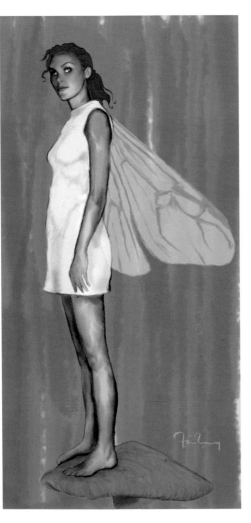

3 Choose a colour scheme that you feel is most appropriate. In this case the colours are kept very light with a hint of green. The red hair makes a strong contrast to her ghostly green eyes, which emphasize her non-human nature. The dress is simple, not at all elaborate, the hair is girlish, also without elaboration, and she has a small, turned-up nose and fresh, scrubbed features. The toadstool denotes her diminutive stature.

Combining influences

It is important in fantasy art to go beyond the obvious. This character is an interpretation of the Egyptian cat goddess Bast, but she is not obviously Egyptian in her style or look. The main influence is Siamese cats, whose distinctive colouring makes them appear to be wearing stockings and long gloves; this could be sexy applied to a humanoid figure.

Angels and demons

Most winged figures are inspired by the Christian mythology of angels. This drawing was made from a sculpture in a museum in Copenhagen, Denmark. She bears the classic hallmarks of 19th-century religious iconography: a flowing robe, a garland of flowers and strong, detailed wings.

This angel, however, is another matter entirely: she has massive wings which spread out behind her, symbolic of a mass of flowing hair, and she sits naked and confident, with a half-smile crossing her dark features.

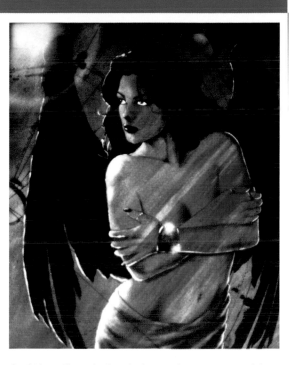

And then there is the dark angel type – a notable contrast to the traditional Christian iconography.
Dark Angel by Bob Hobbs

'Succubus' is the name given to a female genie. This sketch was an idea for a perfume manufacturer and was originally meant to appear as a half-human, half-bottle hybrid.

Like the cat goddess, this character does not play to the stereotype of a dark-skinned, curvaceous female genie. Instead she is extremely pale and bony; note how her hands are unnaturally large in proportion to the rest of her body. The curve of her body is unrealistic but is designed to appear as an elegant flowing shape; as such, she works well on the eye.

Shakespeare's play *A Midsummer Night's Dream* had a tremendous influence on the development of the fairy myth and has inspired artists for centuries.
Titania by Seyburn Colclough

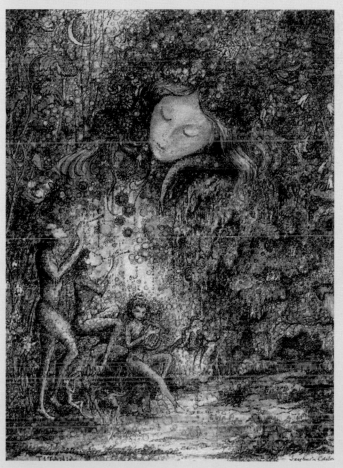

Shadow creatures

Tone and shadow can be added to your characters in a variety of different ways. Ink and ink pens are used to produce strong black-and-white images, pencil can be used for greater tonal variety, and markers can be used for colour and shadow tests.

1 After producing a rough sketch such as this, you can choose which medium you want to use to develop it further.

2 Working with pencil allows a great deal of expression. You can create shadow within shadow and explore different methods of detailing as you go along. Pencil has the advantage of being easy to change, but may not have much impact on the eye.

3 Without eradicating your pencils, try using a lightbox (or tracing paper if you have no lightbox) and draw a version of your character using technical pens. This example was drawn using .5mm and .8mm nibs. I always put a thick outline around the character to give it impact.

4 Use magic markers of varying tones to do quick colour and shadow tests. This medium is favoured by the film and advertising industries. The inflexible nature of the markers makes them hard to work with at first, but the techniques are very effective.

5 You can then trace over the marker test with technical pens to produce a finished 'visual'.

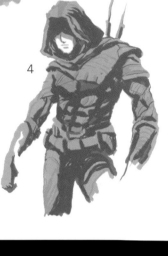

5

3

4

2

1

Dark into light

Shadow can be used especially to enhance the atmosphere in an illustration. In this example the shadow 'eats' away at the figure until very little of the dress is seen. By playing around with the amount of shadow you can create different visual effects and provide yourself with shortcuts by cutting out the need for certain details – for example, if you don't like drawing feet, you can avoid having them in your work!

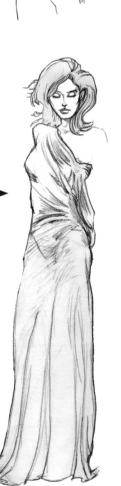

Light out of dark

Consider how you will use shadow when you are designing your original character. In this case a great deal of heavy shadow was used on the face, so it was unnecessary to draw the details of the features. The atmosphere of this image is enhanced by the use of only one other colour, creating a 'noir' effect.

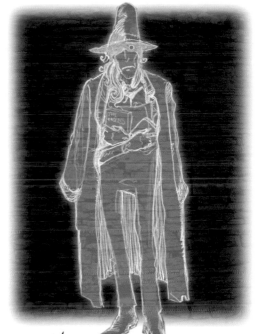

Translucency

Ghosting effects are easy to achieve in Photoshop. This image of a Gothic ghost was drawn in pencil then inverted in Photoshop so the black lines became white. The opacity was then decreased so the background wall could be seen through the figure.

If you are not using Photoshop, try working on black card with white pastels, pencils or Conté pencils. You can also try covering a sheet of paper with pencil tone then using a fine eraser to draw figures out of it, as shown here.

Full shadow

Figures drawn in heavy shadow, such as this vampire, can be given a white inline so they don't appear in complete silhouette. You can also bend the rules by allowing a few details to appear, such as the embroidery around the collar area.

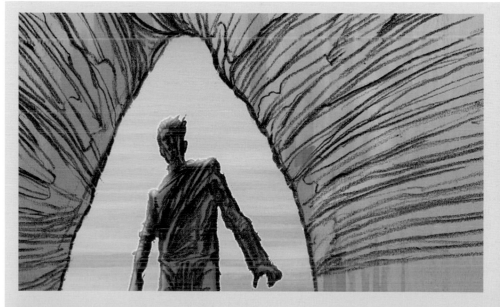

Backlighting

Figures appearing in entrances often appear backlit. If the light is behind them, most of the figure will appear in shadow, with a highlight around their outer edge.

Birds

Birds and feathers are notoriously difficult to draw and should be avoided in most cases. However, if you have an affinity for these weird members of the animal kingdom, you may want to try a few techniques for stylizing them.

Skua

1 When drawing birds, focus on the energy flow in the same way that you do with figures in action. In this drawing of a great skua you can see how the spine and its relation to the wings are the most important – this is the birds' equivalent of the centre line. You can then 'hang' the ribcage on to it.

2 Use photographic reference to draw the wing feathers of the bird accurately. You can see how the flow of feathers follows the angle and positioning of the wings. There is a great deal of harmony in the shape of birds, so use soft, flowing curving motions of your pencil.

3 Don't forget to stylize and take your creation somewhere else. In this case I was playing with the idea of a species of bio-mechanical birds. I was looking for something that was neither robot nor biological, so the lines had to reflect that.

These creatures are so common that we rarely notice how bizarre they may appear. This skeleton says it all ... no wonder so many people are scared of them.

Sparrowhawk

1 The sparrowhawk has particularly strange physiognomy. It has extraordinary long legs and razor-sharp talons that are used for taking small birds on the wing. You can see from this sketch that it also has highly developed 'thighs' and the enormous eye sockets typical of raptors.

2 After roughing out your basic shapes, you can continue to break the subject down into manageable blocks. Notice how the angles of the head have been created by 'slicing' off the corners of the original oval shape. The wings have been created with the same soft curving lines used on the great skua, and the volume of the chest has been indicated by the markings that are typical of this type of hawk.

3 Again the bird has been stylized into a biomechanical monster. Flat colours have been used and there is no tonal work. Depth has been defined by use of slight colour variations. Special attention has been given to the distinctive markings of the bird, and these have been used to emphasize its expression and define its character.

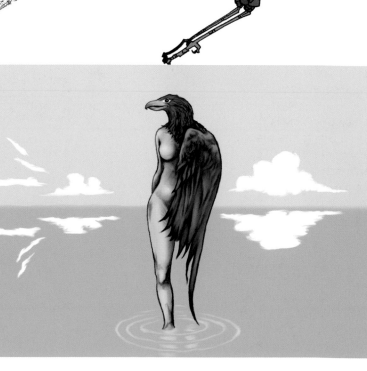

Human-bird hybrids are a mainstay of fantasy art, particularly in the work of the Surrealist painter Max Ernst. This painting was an unused idea for the Alan Parsons Project.

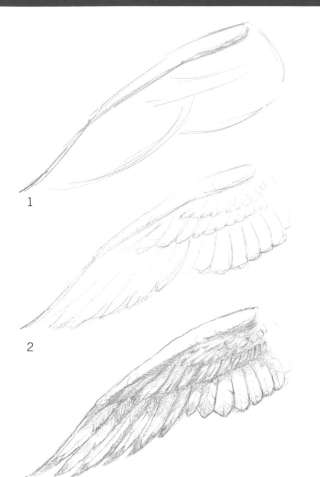

1

2

3

Owl

Owls were once greatly feared and their presence was considered a bad omen. Nowadays they represent wisdom, and the use of one as a mascot is said to bring good fortune in any kind of study. Owls are so strange-looking that drawing them can be infuriating; their enormous eyes and delicate feathering require careful observation and attention to detail.

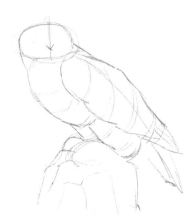

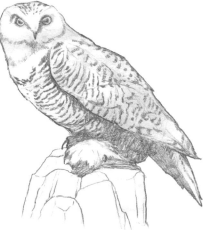

1 Start with the rough shapes. Notice the squashed oval skull and the comparatively large appearance of the legs surrounded by a thick layer of feathers.

2 You don't have to draw every feather; you can see here how I have used the elegant markings of the bird to delineate its body shape. The lighter feathers around the eyes and chest have been drawn sparingly, using smaller, softer pencil strokes.

Feathers

1 Feather patterns vary from bird to bird, but the general arrangement can be hung on an arm-like skeleton. Add the general divisions between feather sizes to indicate where they will overlap.

2 When pencilling in the feathers, aim to give the array a harmonious flow and pay attention to overlaps. Don't make the pattern too rigid: allow for a little variation, a few gaps and inconsistencies here and there.

3 Further detail can be added, such as a chevron on each feather. Use shadow to fill in awkward gaps and inconsistencies. Note that the shadow is darkest where the wing joins the body.

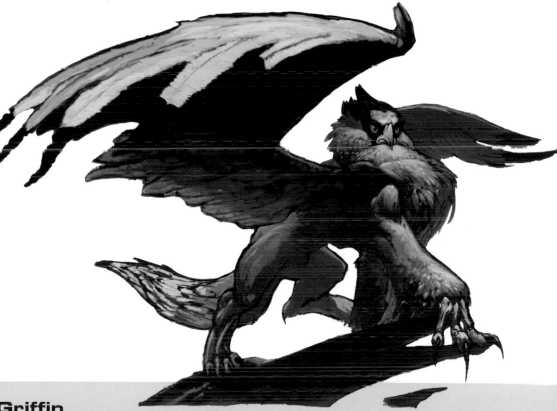

Griffin

The griffin is another classic mythical creature that can be interpreted in a variety of ways. Note the extreme styling given to the wings and body of this specimen.

Griffin by Anthony S. Waters; © Wizards of the Coast, Inc. Used with permission

Quadrupeds

Four-legged beasts are absolutely essential for any aspiring fantasy artist. Horses are the main form of transport throughout the genre – which is why we are going to ignore them completely and try and be a bit more original, which is, after all, our main aim. Most quadrupeds are similar, so whichever type you learn to draw, you will find it easy to master all the others.

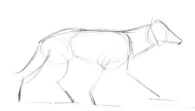

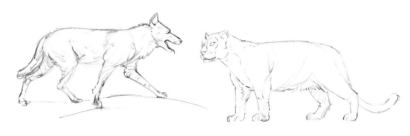

The goat is based on a photo of the Himalayan markhor, which has amazing spiralling horns and a long beard. Note the difference in the skull shapes of the wolf and the Persian leopardess – the wolf has a much longer snout and larger ears. The leopard has noticeably larger paws.

Compare the basic sketches of the three animals shown at left. Note the shape of the goat's spine compared to the others – it slopes more towards the back.

The leopard is more stocky, with shorter legs and a longer body, and the wolf is leaner with longer legs. The basic head shapes are similar at this stage. Start with the curve of the spine, then add the large oval for the ribs before adding the legs, neck and head. The wolf is similar to the leopard, but leaner.

Now for the fun part. Just because it's a leopard doesn't mean it has to be leopard-sized. The addition of a pair of warrior women increases the size of the leopard to enormous proportions. Elaborate armour is added to enhance the majestic quality of the styling.

The goat is given much longer fur than the original, and now it's blue – why not? The addition of a fat goblin makes this creature appear less majestic and more of a beast of burden. Note that all the animals are given a hard saddle on top of a soft blanket, the only concession made to reality.

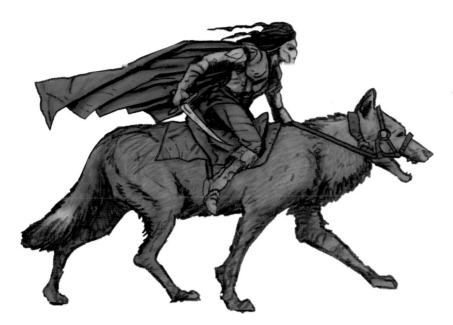

Fur

1 For a rough indication of fur, start with a base colour.

2 Add general shadows

3 Work into it with small dark lines.

4 Work over it again with lighter lines going at slight angles to the dark lines, then go over again with dark lines to break up the patterns and build texture. The more you go back and forth like this, the better it tends to look.

The wolf is a fast-moving predator, so it makes sense to give it a warrior rider, suggesting that this is a battle steed rather than a beast of burden, which seems more appropriate. The original grey colouring of the wolf has been kept.

Hybrids and combinations

Don't limit yourself to what exists. Try impossible hybrids such as this tiger-giraffe, which looks quite good in a comical sort of way.

The creature at right is included to show that there should be no limits to what you can do. In this sketch for an album sleeve, I have crossed an antelope with ... a table, for a thoroughly surreal result.

Dragons

Dragons are one of the great icons of fantasy art. Their status in myth is clearly influenced by giant snakes, komodo dragons and sea creatures. You can use a variety of references to construct them.

Use your knowledge of birds and reptiles to create the centre line of the dragon, which will give the drawing its dynamic and energy flow. Note how the wings appear as if they were arms, giving the creature more character.

The head was inspired by this drawing of a crocodile skull in a museum.

The wings were inspired by the leathery wings of bats. Note how the shape has been modified to suit the energy flow of the dragon.

Colouring wings with pencils

1 It is usually best to work from light to dark with pencils, Begin by laying down a cover of two complementary colours, such as orange and yellow.

2 Add mid-tones such as brown, starting in the dark corners and working outwards following the shape of the wing.

3 Continue to add more and more colours gradually to create depth. You can finish with a hard line in black.

1

2

3

Body shape

The body of the dragon is like a tube, taken from this drawing of a snake skeleton.

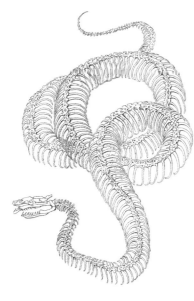

You can create the shape by spiralling along the centre line with your pencil. Note how the position of the centre line of the body changes as it twists and curves around.

Drawing scales

The skin of a dragon can be based on the scales of a reptile such as a crocodile or, in this case, this amazing hassar fish with its strange overlapping scales.

1 Begin by drawing the upper scales; I added a bony protrusion at the top, work your way down the figure, underlapping the scales as you go.

2 Then add the lower scales and shadow detail on each scale.

Inking scales

1 When inking scales, start by doing them all with a clean line.

2 Then you have to add a shadow under each and every one; see the difference this makes.

3 Add further shadows if you wish.

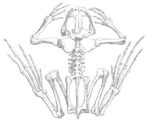

The feet were inspired by this drawing of a frog skeleton, found in an old book.

Behemoths

Creating fantasy beasts requires the artist to find a balance between the plausible and the imagined. If a creation has some resemblance to reality, this can enhance its fantasy element. Much of fantasy art is a matter of making the imagined look as real as possible, and for this reason it is useful to experiment with making hybrids of other animals and playing around with the possibilities of 'cross-breeding' creatures to the best effect.

1 Take the humble camel, whose miserable lot in life is to carry salt and spices around the deserts of the world. Rough out its general shape as shown here, noting the large stomach area.

2 Add the detail, including the harmless, doe-like eyes and peaceful mouth, the soft furry body and spindly legs.

3 Now turn it into something to be feared — you could give it the scales of a crocodile, or spikes or long hair. Armour has been added, and the creature's increased dimensions are suggested by the small hut carrying several warriors on its back.

Colouring scales

1 The basic principles of colouring apply to all media, whether they be paint, pencil or digital, and the same approach applies whether you are applying colour to scales, armour or clothes. Start with a base colour.

2 Add general shadows in broad strokes. Here this was done using the Burn tool in Photoshop.

3 Then add highlights. Working in paint, you blend the shadows into the base while it is still wet and add the highlights later when it is dry. The beauty of digital is that it is always 'wet', and you can come back to artworks years later and still be able to blend the colours using the Smudge tool.

Elephant

These benign creatures were used as battle beasts for centuries, so it makes sense to use them as a starting point for a fantasy behemoth. Copy the general shape of the elephant (left), paying attention to the peculiar shape of the skull.

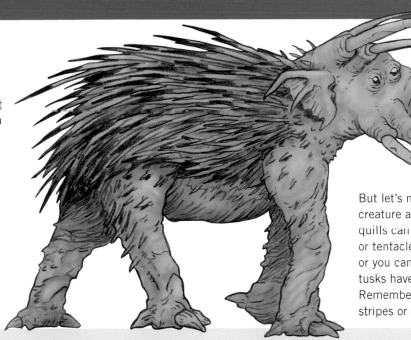

But let's not stop there. Create a new creature altogether. Huge porcupine quills can be added – or maybe feathers or tentacles? The trunk can be cut off, or you can add more. In this case more tusks have been added, and extra eyes. Remember to think of colour too – what stripes or spots can you invent?

Killer whale

Sea creatures can be a great source of ideas. The killer whale or orca has smooth, bold lines that are easy to copy, and distinctive markings.

An extra fin is added, the colour scheme is changed and the flipper is modified. Now, just because it's based on a sea creature doesn't mean it should remain a sea creature. This new behemoth is seen floating with its rider above a desert landscape. How does it fly? Who cares? This is fantasy.

In this example, a new species of sea creature has been created as a composite of elements from a variety of other creatures.
Krink by Anthony S. Waters

Aliens and other species

Strictly speaking, aliens fall into the category of science fiction, but there is increasing overlap in the genres and a great variety of semihumanoid species inhabit the world of fantasy. From elves to banshees and from Medusa to the Minotaur, mythical variations of the human type are infinite.

1 This drawing was made from a photo of a Burmese woman. In order to make her into a new species I tried to think of her being made from something other than flesh and bone. In the end I decided she would be formed from crystals and have a pearlescent texture.

4 With the third variation I changed the eyes again then added lots of tentacles inspired by a drawing of an octopus. I also radically altered the colour scheme.

2 She was coloured in Photoshop using cool, icy hues to emphasize the crystalline quality of her skin.

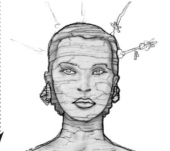

3 Try starting with the same figure and redesigning it with different materials to create new species. In this case she was fleshy, like a human, but I gave her alien eyes and a hard, boned hairpiece with sharp, almost metallic fronds.

Robot
This robot was inspired by both the human skeleton and human musculature. However, it is neither one nor the other; mixing the two areas of reference has thrown up an entirely new physiognomy. The elements of the figure are not symmetrical – these figures do not have to adhere to the rules of human proportion or balance.

Quick digital colour visuals

There are many ways of using Photoshop. This may not be the best, but it's a very quick method for producing colour visuals.

1 Make a drawing with a strong, unbroken line all the way around it. Scan it then use the Magic Wand tool to select the area around it. Then select the 'inverse' so the defined area is the picture.

2 Make a new layer. Use the Paint Bucket tool to dump a single colour over your image in the new layer.

3 Set the blending mode to Multiply so you can see your drawing through the colour layer.

4 You can use the Lasso tool to select different areas of the colour layer and then use the Hue/ Saturation dialogue box to change the colours. You can also do this by using the Magic Wand tool to select areas on the drawing layer and then switch to the colour layer before changing the colours.

With this method, all the different elements of colour start at the same place, which allows you to keep a fairly narrow range of colour and tone. The trick is to make the differences in colour very slight and subtle.

5 Use the Dodge and Burn tools to add further shadows and highlights. The trick here is also to keep it very subtle: I use an exposure intensity on the tool as low as 3–4 per cent.

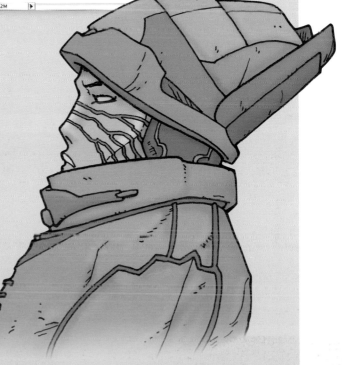

This is where the real magick began ...

1 First I opened the scratch background image and separated the image into two layers by selecting and removing the black lines from the background and placing them on their own transparent layer. I changed their colour to a blood red, then added a layer below and filled that with black.

2 Next I opened up the skulls image. Through duplication of the layer and a little erasing and black airbrushing, I changed the image to make it look a bit more like a pile of skulls.

3 I merged all the layers except the bottom black background layer. Then I clicked and dragged the merged layer to the scratch background image.
 When doing this, be sure to click on Layers in the layer menu window, select Layer Options, then type in a name for that layer. It's a lot easier to find the layer you want when they start to pile up.

4 I then selected an Airbrush Eraser tool and carefully removed some of the black around the skulls.

5 Next I opened up the Philadelphia map image. I selected and changed the colour of the line art to light grey, then I clicked and dragged that layer on to the scratch background image, which I now called the 'working image'. Using the Airbrush Eraser tool sparingly, I removed some of the map so it didn't look so pasted on.

6 I opened the Abigail parchment and used the Lasso tool to cut out a rough-edged segment of the parchment, deleting the rest. I clicked and dragged the cut-out on to the working image.

7 I moved the Abigail parchment to a lower layer behind the skulls. Then, using the layer opacity slider, I reduced the transparency to about 62 per cent and added a render lighting effect filter to reduce the legibility of the letter even more and give it a ghostly look.

7

8

9

8 Next I opened up a scan of a geometrical symbol I had obtained from a book of copyright-free clip art. I changed the colour of the lines to a yellow I picked from the Abigail parchment. I then enlarged the symbol a little and moved it up near the top of the working image.

9 I then opened a set of Tarot card symbols and dragged them into the working image. I left them black to add a bit of contrast to the overall image and also to introduce an orderly element into the otherwise mostly chaotic composition.

10 Opening the list of Watchers' names, I changed the colour to a deep orange then dragged them to a spot in the lower right to break up some black space. I also added a drop shadow to enhance the text.

11 Next was the 3D male figure. I dragged him into the working image then selectively airbrushed parts of him out but left his face intact and visible

12 I added the same lighting effect filter used on the Abigail parchment.

13 The Seal of Vine was opened next and placed in the geometric diagram. I did this to further enhance the connection between magick and mathematical symbols.

14 Finally I opened the photo of Deanna and placed her in the working image near the upper right. Then I flipped her so she was looking in towards the space on the image where the title of the book would go later.

11

12

13

14

10

At this point the illustration was largely finished. But there was something missing. The story involves a young woman who is being pursued by an Internet stalker/serial killer, so I needed to add something that reflected that. I went to my 3D Studio MAX software and found an old laptop monitor screen I had created for another project.

20 Having changed my mind about the male figure, I flipped him horizontally so that he fitted better into the right-hand side of the composition.

15 I rendered the screen out as a Targa file and saved it to the folder where all the other elements were already stored.

16 I then opened it in Photoshop and typed in the text from a real email message. I took some artistic licence and made the text green and creepy-looking – some of you may remember the old days before colour computer monitors.

17 I applied the same lighting effect I used before to keep the colouring consistent, and then added a slight drop shadow to the layer.

18 I placed the monitor in line with the two figures on the right-hand side.

19 Now the image was almost finished; it was at this point that the 'tweaking' began, where elements could be moved about, colours altered, pieces added or removed. For example, I added an archaic magickal symbol known as the Solomon pentacle to enhance the occult aspect; the circle also added to the flow of the composition.

15

16

17

18

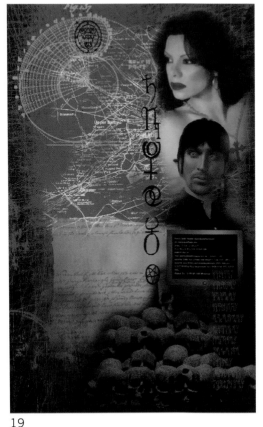

19

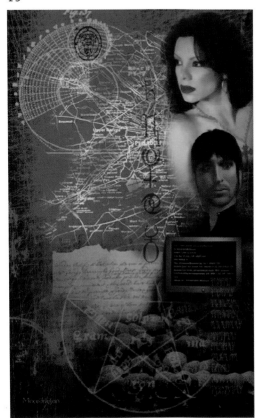

20

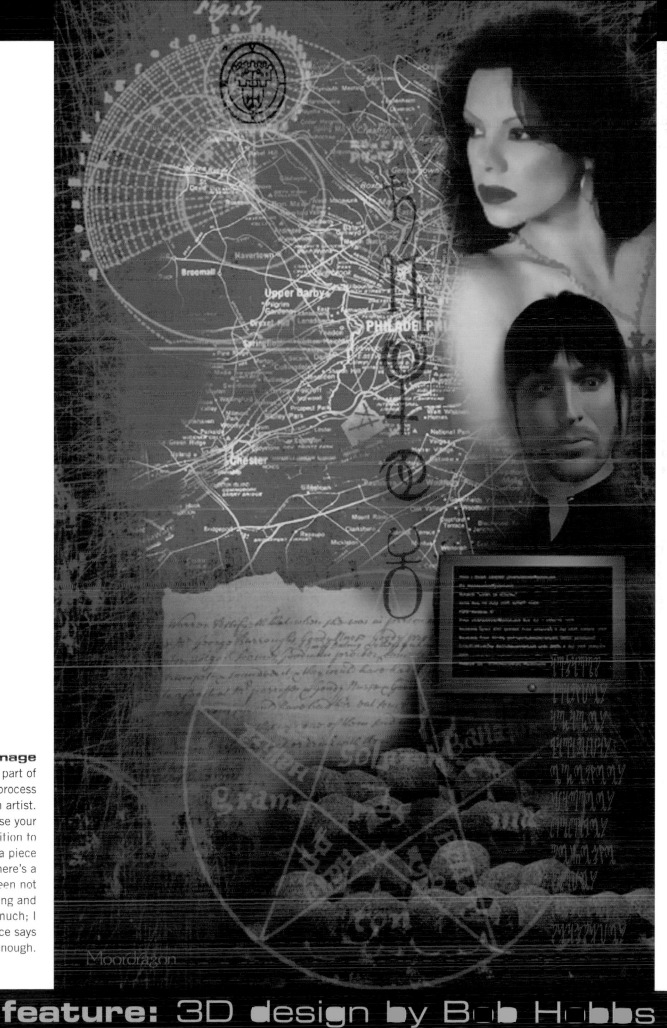

Final Image

The tweaking part of the creative process differs for each artist. You have to use your own intuition to determine when a piece is finished. There's a fine line between not saying anything and saying too much; I think this piece says just enough.

Hardware

When it comes to designing and drawing machines, vehicles and weapons, it is necessary to learn the basic rules of perspective first, as these come in very useful when you need to execute convincing scenes involving siege machinery, weapons of destruction and general all-out carnage. Research and observation of existing technologies, both ancient and modern, will also serve to inspire and educate you in the fine art of pitching armies against each other in remorseless bloody conflict.

Another Perfect Day by Finlay

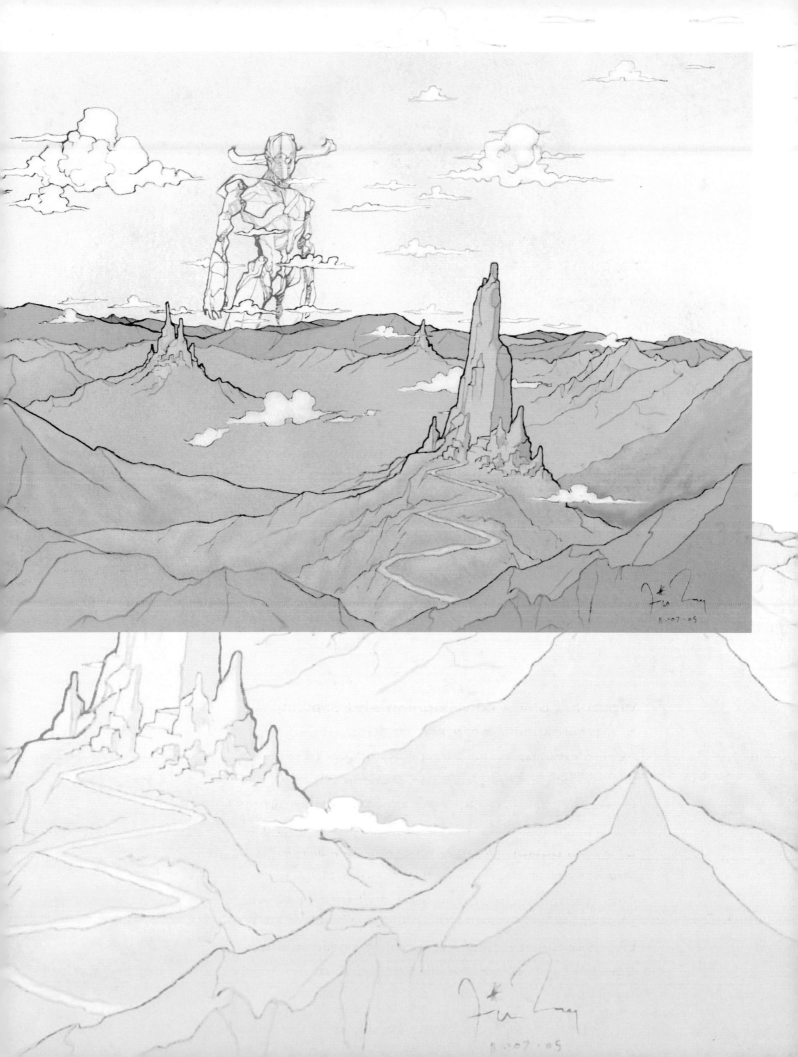

Weapons

The sword has had a powerful symbolic meaning throughout the ages, and legends such as that of King Arthur and the sword in the stone have survived for centuries to regale audiences in modern times. The sword is more than just a weapon in the fantasy genre; it can be taken to mean truth or protection, and it can have magic powers or a mind of its own. Swords often have names: Arthur had Excalibur, Dorian Hawkmoon had Mournblade – and even I have a sword called Miffy.

Many museums have fine collections of weapons and swords from throughout history. Medieval European weaponry is a common choice for fantasy artists, but Middle Eastern, Asian and Oriental weaponry also boasts breathtaking ornament and outlandish invention.

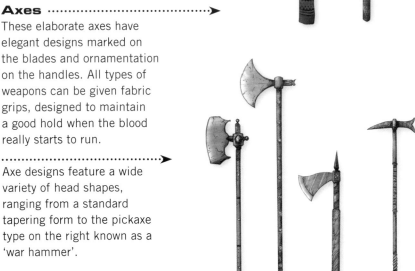

Daggers

You can use construction lines to build your weapons. Note how the lines drawn here are roughly in perspective – this will help you to craft the lines and forms of your weapons.

Scabbards are used for carrying swords and protecting the blade when it is not in use. You can try different styling solutions for your swords and scabbards so they match. This set follows an eagle theme, and you can see wing, claw and head motifs in every aspect of the design.

Axes

These elaborate axes have elegant designs marked on the blades and ornamentation on the handles. All types of weapons can be given fabric grips, designed to maintain a good hold when the blood really starts to run.

Axe designs feature a wide variety of head shapes, ranging from a standard tapering form to the pickaxe type on the right known as a 'war hammer'.

Hilts can be highly ornamented with elegant designs in gold or silver. The hilt near left shows how jewels and precious stones such as lapis lazuli can be inset. Try mixtures of wood, leather and metal on the handles.

Swords

Swords come in an enormous variety of shapes and sizes; these examples are from India. The scabbards have clasps and straps for attaching them to belts.

Shields

This is a typical Greek hoplite shield, beaten from metal with a design painted on the surface. It is said that battles were often short but soldiers had plenty of time waiting for them to begin, some of which they would spend decorating and personalizing their equipment.

You can design your shields in any shape imaginable. This example is known as a 'Persian cello' for obvious reasons. It was made from a sturdy wooden frame covered in tough leather.

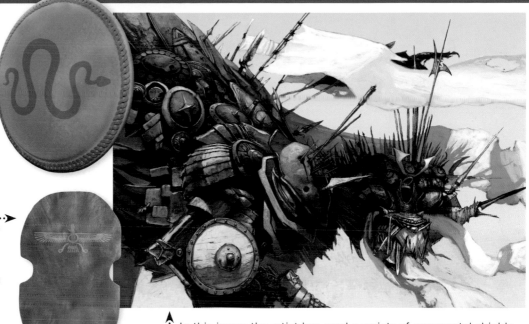

In this image the artist has used a variety of ornamental shields and weapons to create a fresh look for a battle animal.
War Elemental by Anthony S. Waters; © 2005 Wizards of the Coast, Inc. Used with permission

Bows and arrows

In their time bows and arrows were highly efficient weapons, and a good battalion of archers was essential to an army because of its ability to wreak long-range devastation on the enemy. Bows could be highly ornamented and usually had elaborate hand grips.

Bows would often have ornamental heads called 'sirras', carved from bone or wood in the shape of animals or mythical beasts. In this example a notch and groove have been incorporated to hold the bowstring.

Standards

Standards were ornamental flags used as rallying points by soldiers amid the chaos of the battlefield. They could be simple flags or pennants, or more elaborate, such as this one.

Slings

Slings were another effective method of long-range killing, capable of throwing missiles of stone or lead with deadly accuracy. These examples were made of leather, twine and, in the one on the right, with a wooden stick.

Machines

Most fantasy machinery is based on medieval equipment, and the versions we see in films are usually logical and possible, just more elaborate than their ancestral forebears.

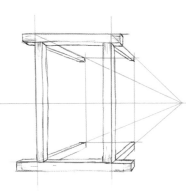

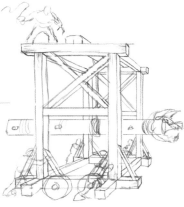

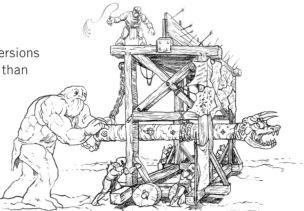

3 I did the final drawing by tracing off on a lightbox, but this isn't strictly necessary, it's just a cleaner way of producing the final artwork. Note how the texture lines and shadows on the beams tend to follow the lines of perspective and strengthen the overall dynamic of the drawing. I added animal skins stretched over the front of the ram, as used in ancient times as protection against the withering hail of arrows that would rain down on the besiegers.

Battering ram

1 Begin by marking out a rectangular box in perspective. It is best to put in the main construction beams first before adding detail.

2 This kind of machinery would be subject to heavy shocks, so it is important to build it from thick, heavy beams; there would also be a lot of extra joists to make it stronger. You can then begin to add figures around it.

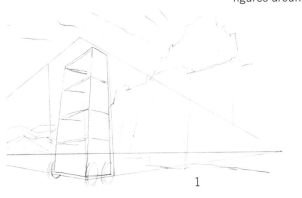

1

Siege engine

1 Draw a tall box in perspective, but note how the siege tower is angled on one side. You can put in a rough indication of the castle walls, which follow the same lines of perspective (see pages 92–95).

2 Add some general detail. This is the stage where you have to come up with all your ideas. What is each figure doing? How do the mechanics of the tower work? You can see that I haven't worried about drawing over the construction lines of the tower as I've added figures. It's more important at this stage to flesh out the image with all its necessary contents.

3 Again, I used a lightbox to do the final drawing so that I didn't have to worry about fiddly eraser work where figures and objects were overlapping. Compare this with the previous sketch, and you can see how I have built on the contents of the first drawing, adding more detail and refinements. Working in stages like this allows you to develop each tiny element with each successive version of the drawing.

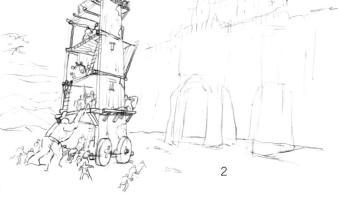

2

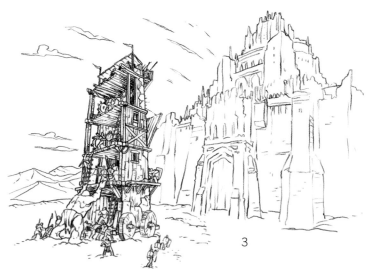

3

Catapult

1 Begin with a box in perspective and do a rough version of the heavy beam construction of the catapult. You can see how I've used this stage of the drawing to work out the operating mechanism.

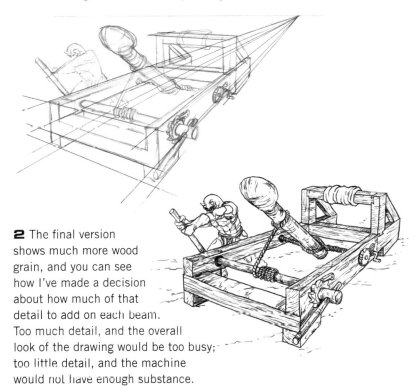

2 The final version shows much more wood grain, and you can see how I've made a decision about how much of that detail to add on each beam. Too much detail, and the overall look of the drawing would be too busy; too little detail, and the machine would not have enough substance.

You can find a great variety of weapons in history books that will give you plenty of inspiration for your own instruments of destruction. Just remember to build on what you find: always try and make it more elaborate and fantastic than the original.

Always try and add something new and interesting to your design. In this case some Celtic style ornamentation has been developed.

Dwarven Catapult by Anthony S. Waters; © 2002 Microsoft Corporation; reproduced by permission

Victorian fantasy

This style of fantasy art has become increasingly popular in recent years. Rather than using ancient and medieval technology as its inspiration, it looks to the age of steam power for its references.

1 As usual, begin by constructing a machine or vehicle from basic shapes. In this case it is a large sphere with a platform on top and some crab-like legs below.

2 Now, this machine bears no resemblance to anything built in the 19th century – it is simply a matter of using the same kind of materials and mechanics as they did in those days and exaggerating them. So you can see lots of iron and brass, plenty of rivets and bolts and lots of elaborate steelwork with ornamental curves and railings, not to mention boilers, flywheels and pistons.

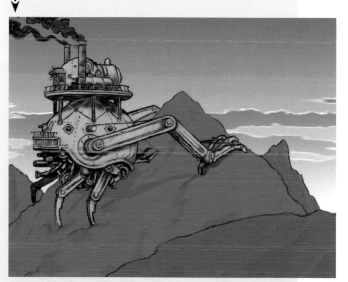

The best resources for this kind of design can be found in Britain. Look at the construction of railway stations such as Paddington in London and bridges such as the Forth Rail Bridge in Scotland. London's Science Museum has an excellent collection of model machines and boats that will give you all the detail you could wish for. You can also check the Internet for places such as Ironbridge in Shropshire, the cradle of the Industrial Revolution.

Vehicles

At the heart of every fantasy adventure lies the notion of the quest – the incredible journey that sees heroes crossing vast distances and visiting the most incredible places. It follows, then, that transport plays an important part in your creation of a fantasy world. The choice of starting points is infinite – from traditional vehicles, such as carts, ships and hot-air balloons, to bizarre hybrids of animals and steam-driven engines.

Carts

Start with a circle in a square to draw a wheel in perspective. Draw a box in perspective like the one shown here (see page 92), then add diagonals across the front of the box. Where these lines meet gives you the centre point of the wheel, and you can draw the horizontal and vertical lines that divide the box in four. You can then use this 'grid' to form a circle by drawing one quarter at a time.

1 Ox and cart would be the standard form of transport in your average *Lord of the Rings*-type world, unless you were wealthy and powerful enough to own a dragon or a winged horse. You can see from this sketch how you can form accurate curved shapes, such as the canopy of this wagon, by working inside a box drawn in perspective.

2 Using perspective in this way gives the final drawing strength and a sense of depth. Note how thick outlines have been used on the woodwork to help define the shape; this is done by going back over the original pencil lines and strengthening them until the drawing feels right. Shadows are usually added right at the end.

Boats

History has left us with the most incredible diversity of marine vessels to draw inspiration from. You could quite happily set your entire fantasy world on a vast ocean, and you would never get bored discovering and inventing new types of sea-going transport.

Of course, you don't have to stick to the tried and tested. Your modes of fantasy transport can be completely illogical and impossible!

1 This vessel is based on a typical cargo ship of the 19th century; these vessels were so effective they were still in use long after the advent of steam. Begin with a rectangle and draw the hull inside that; the lines of the hull are all curved, which lends an elegance to the overall design. Note also that the masts are not perfectly upright: they slant back, and this adds to the streamlining of your drawing. After adding your masts, create an outline for your sails; here they overlap.

2 Add detail to the masts and beams by adding lots of little lines on each one. Add some indication of planks on the hull with long broken lines. Add a few objects on the deck; a lot of these will be covered up by rigging.

Dragonfly boat

1 Fantasy vehicles can be hybrids; they can be a mix of anything you like, in this case a dragonfly and a boat. Begin by drawing some perspective lines – now, the lines drawn here aren't 100 per cent accurate and you will find that, with practice, you don't always have to use a ruler to get your perspective lines in. In fact, I never use a ruler: I just throw down a few whiz lines to get the overall feeling of the perspective, and this keeps my approach much more fluid and organic.

2 The perspective lines have allowed me to 'sculpt' the organic shape of the boat, and have ensured that the uprights are strong and reasonably accurate.

3 The colour scheme is based on that of a dragonfly and is fairly consistent, save for the figure in the prow, who has been coloured to make him stand out. The wings are paler to give them a more fragile appearance. The tail fin of the boat is based on the gondolas of Venice. Needless to say, a boat like this would not realistically be able to fly – as usual, when you are designing, begin with reality ... then leave it far behind.

On the other hand, this hot-air balloon boat actually existed and would need little elaboration to fit into a fantasy world, which suggests that fantasy and reality are sometimes closer to each other than we think.

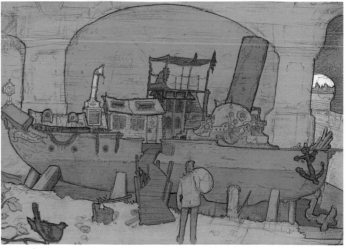

3 Now add lots of loose, fluid detail to the sails; without this the whole thing would be a mass of confusing lines. Also look closely and add a few shadows here and there, by the masts and under the sails, which help give substance to the drawing. Then, of course, there is the rigging, masses of it. You should be careful here to find the right balance – my reference picture had a lot more rigging than my drawing, but this would have made the whole thing very messy.

This is an example of Victorian style fantasy. This boat was entirely invented; the aim was to produce something a bit magical, something that looked like it had a lot of stories to tell. It's the kind of vessel you would want to explore, get inside and learn all its secrets.

From The Memory War by Finlay

Futuristic concepts

The 'concept' for the image often comes first, an idea that will affect the way the reference material is used. The style and look of the design is then moulded to fit the idea, and it is this relationship between concept and style that creates a sense of the fantastic.

Styling futuristic machinery

1 Science-fiction machinery tends to be very fluid and streamlined, and often takes its cues from the animal world. Begin by playing around with a variety of basic shapes, angles and curves until you start to see something that is attractive to you. It took several attempts to get to this version, which has a spiky quality and seems crustacean in its design.

2 It's good to have a clear picture in your mind of what your machine will look like, but it is not essential. In this case it was a matter of doing a few versions on the lightbox and just exploring the different elements of the vehicle as I went along. Sometimes you don't know what you want until you see it.

3 I added shadow and highlights with more pencil work, and used a fine eraser to create some sparkle here and there.

4 I got this metallic effect by using the Smudge tool in Photoshop. You can get similar effects by smudging with your fingers if you are working with pencil or pastels, but this takes a bit of practice and you have to work big to get the detail. Computer design software has many excellent filters and plug-ins for creating metallic effects, but I use these very sparingly as they tend to make everybody's work look the same. It's more time-consuming to do it 'by hand' with the Smudge tool, but allows you more control in the long run.

5 If you are working with markers, you need to use bleedproof paper and work on a lightbox. Leave white areas in the drawing to get a more metallic effect.

6 I used black marker pens to add the line drawing afterwards.

Futuristic ideas

This sketch was produced as an idea for Pink Floyd's *Pulse* album. The aim was to design a spaceship that somehow represented 'light' and 'sound'. The large funnel, based on flowers and butterfly wings, represents sound, and the huge balloons, based on luminescent jellyfish, represent light.

5

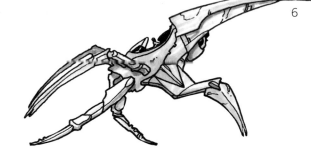

6

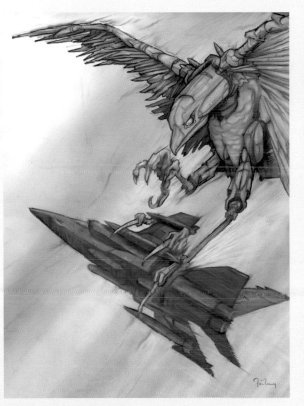

At right is a more direct form of reference – a giant metallic sparrowhawk, recognizable by its long legs, takes out a Tornado jump jet.
Raptors: Down to Kill by Finlay

A more surreal approach is explored below, in the album sleeve for a rock group. The two figures have Lockheed Starfighters in place of their heads.
Get Your Machine Out by Finlay

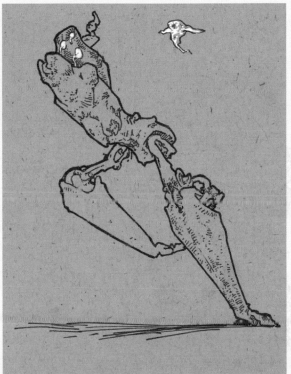

The runner above right is clearly mechanical, but its forms are purely organic.
Plains Runner by Anthony S. Waters; © 2005 Hasbro, Inc. All Rights Reserved

At right is an 'autonomous disposable killing machine, designed for guerrilla operations'. Machines do not have to be symmetrical or metallic in appearance.
Bug Buster by Anthony S. Waters; © 2005 Hasbro, Inc. All Rights Reserved

feature: Digital painting

by Antony S. Waters

Ravnica Black Land

I was brought aboard the pre-production team for Wizard's Ravnica card set during Spring 2004. The challenge would be to make a world-spanning Gothic metropolis. Scale was the key to Ravnica. Such a massive entity as a global city could be interpreted in a geological manner, with districts, neighbourhoods and industrial centres placed within given layers.

My task was to help develop specific environments for Ravnica. Since Magic is divided along colour lines (Black, Blue, White, Green, Red) and each colour has an associated setting (Swamps, Islands, Plains, Forests, Mountains) and aspect to represent (Evil, Knowledge, Good, Nature, Chaos), it was my task to develop signature looks for each associated aspect of the city.

Black Land concept

This was my first take on what the underworld of Ravnica might look like.

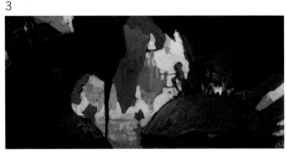

1

Cropped underdrawing

1 I still prefer to work out most of my composition and design issues on paper.

Initial colour

2 I've imported the underdrawing into Painter, pushed the foreground objects nearly to black and started slapping down some (digital) paint.

Introducing some cool values

3 Now I've established a palette, it's time to get the objects in the mid-ground to pop.

Bringing in the greens

4 Acid green's a favourite for Land cards representing Black; I decided against going in this direction in the end.

Separating the greys

5 The first thing I do with any painting is to select the mid- and upper-range values of my underdrawing and set them to a separate layer. This preserves my linework in case I need to refer to it later on.

First pass of colour

6 I've imported the thumbnail, kicked it up to match the size of the original file and started painting over the top of it.

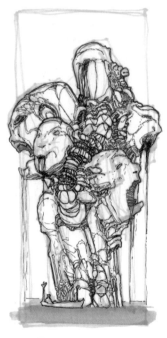

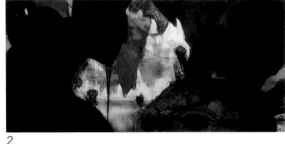

2

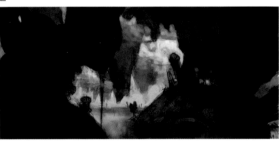

3

4

Swamp pump-heads

There's something wonderfully disturbing about sewage pouring from the mouths, noses, ears and eyes of a statue.

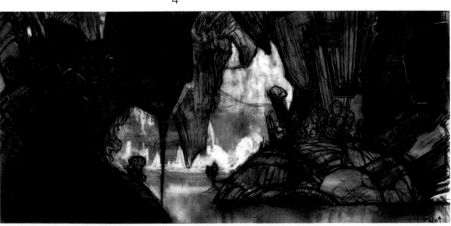

5

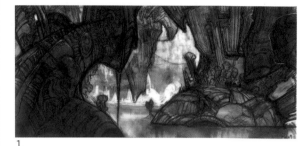

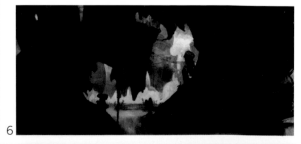

6



Defining the background

7 I've established the shapes of the hanging structures and the atmosphere that surrounds them; however, the way all those background shapes are interacting is beginning to bug me a bit.

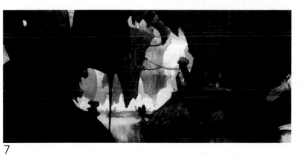

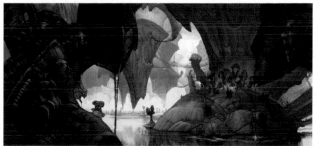

Knocking things back a bit

8 If that weren't enough, the foreground and mid-ground are really beginning to annoy me. So what's the cure? Split up all the shapes on my stage into major bits and distribute them across several layers to play with the composition.

Modifications

10 I thought it would be more interesting to have an execution under way than a bunch of cloaked figures around a fire.

Final art, take one

11 Something's still bothering me about the focal point – the figures near the collection of statues.

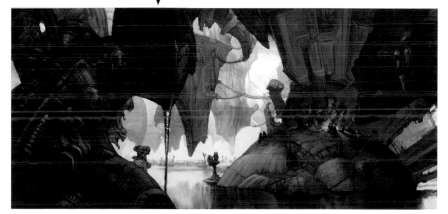

Problem solved

9 Simplifying some of the background shapes manages to soothe my worries.

Final art, take two

12 I added more sludge pouring out of mouths and some scum on the surface of the water to establish that more firmly as a surface, and knocked back the values around the figures to introduce subtlely.

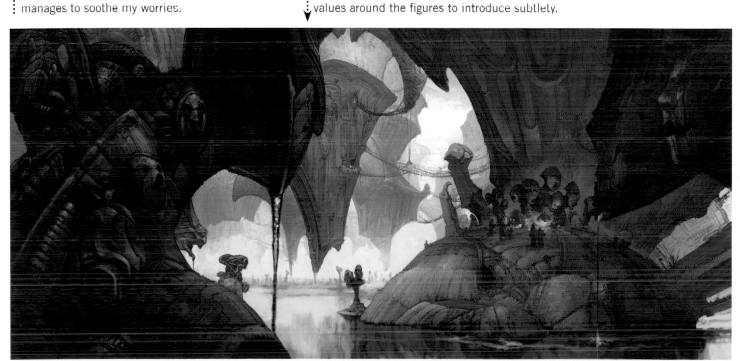

Bone Cavalier

A friend of mine, Jesper Myrfors, recently developed a game called *Clout*. I was one of several people hired to illustrate the game. The demands were simple: he wanted iconic images, quite the opposite direction from the detail-laden work I'd been doing for Ravnica.

The world was a typical fantasy setting, with elves, centaurs, goblins and the like. What made this project exciting to me was the degree of artistic freedom Jesper was granting us. The style guide we were given had large sections of uncharted territory. It was a chance to get weird. And I never, ever miss a chance to do something bizarre.

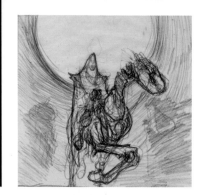

The rough
1 Here's the rough sketch that began the whole process.

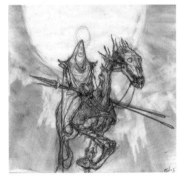

The underdrawing
2 From the rough we get the final sketch, cropped to fit the client's needs. Since the emphasis was on an iconic approach, I chose to not resolve everything in the sketch stage.

Thumbnailing
3 I've imported the piece into Painter, reduced it in size to keep me from becoming obsessed over details, and started adding colour.

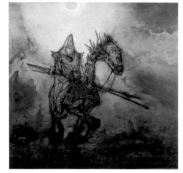

Time to get strange ...
4 Once the rough colours are down I move the image back into Photoshop and begin playing. I begin by importing a scanned photo of a copper wall (bottom of image) from temple grounds in Kamakura, Japan.

... and stranger ...
5 In comes a scan of a sand dollar I collected from a beach in Washington State. It's destined to become a sun. No, I'm not kidding.

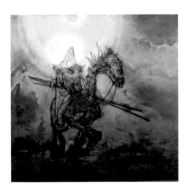

... and stranger still
6 I want more big circular shapes. A photo I've taken of an old rusty train wheel serves that purpose exactly.

This picture needs some bark
7 I'm hungry for more textures, so I grab another scanned picture from Kamakura – this time a close-up of a tree – and drop it in.

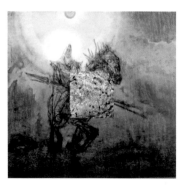

Time to add a muffin
8 I owe Mark Tedin for this scan of a poppyseed muffin. It's given me more fun than any bread product has a right to.

Finally, more wood
9 I import a cross-section of timber, built from a single wedge to strengthen those curves pulling you down on to the undead rider.

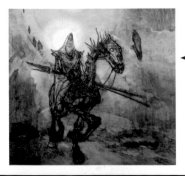

On to the final
10 As noted in my other paintings, I import the final thumbnail, separate my grey values and transfer them to a separate layer.

The painting begins
11 I make a new layer above the rest for painting purposes and start hacking away.

First pass on the background
12 Time to unite all those weird captured textures into something cohesive.

Bring on the fog
13 Obscuring the ground brings the figure forwards and increases the energy focused on the rider.

Starting work on the horse
14 For this I've opened all my books on mummies and other dead things; always use real objects as reference if you're unfamiliar with a subject.

Finished forelegs
15 I've started with the hooves and worked my way up the body. Legs complete: on to the rest.

Boots and cloak
16 Time to take on the Cavalier himself.

Finishing touches
17 I've refined the edge lines of both the rider and the horse's head. Doing so puts them clearly at the bottom of the composition's gravity well.

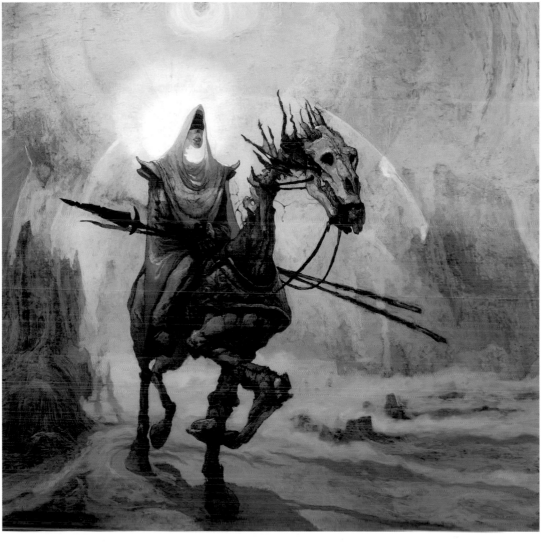

Finito
18 As a final flourish I've blindfolded the Cavalier. If he's dead, he doesn't need his eyes, right?

Digital painting by Antony S. Waters

Drowning

My second assignment for *Clout* involved a pair of what were called Destruction tokens. All that mattered was that I show some kind of calamity befalling a person or creature. Fire had already been taken, so I chose a magical effect for one of the two and a more mundane form of demise for the other: drowning.

What makes the computer so very different from any medium that's preceded it is the combination of photographic, collage and painting tools it provides. You've probably heard of 'happy accidents'. The first part of the phrase is spot on, but the latter half implies you've no control over them, which isn't so. It's a peculiar truism that while 'happy accidents' may be delightful in the spontaneous nature of what they generate, they are, in fact, subject to your will. You can cause them to happen.

Don't ever lose your sense of play. It's in the fooling around that our minds shed all their shackles.

Starting with copper
1 I start this thumbnail with yet another scanned photo of a copper wall.

Paper and paint
2 Here I've added some watercolour paper, teasing some strange effects from it by setting the layer functions to Difference and Overlay, respectively. I've also begun painting over the top of it all. How'd that hand get in there?

More metal
3 A lot of stuff is happening now. I've made several copies of my original linework and set them to different treatments (Hue, Multiply). In addition to the copper wall, I've added scans from samples of pyrite and galena.

Flipping
4 At this point it's become far too disorienting for me to try and paint the figure upside-down, so I simply invert the whole piece. Now it's much easier to work on.

More paint
5 The metal's providing some really good effects, but at the moment it's too distracting; I turn off a couple of layers in order to focus on painting the actual figure.

Refining
6 I'm beginning to get the skin tones under control.

Bring back the metal
7 It's at this stage that I use the metal to mimic the effects of underwater lighting. As with the other pieces, I start my final painting by separating my mid- to upper-range values by making a selection of them in Channels and then copying them to their own layer.

Imports and tweaks

8 I've brought in the thumbnail and duplicated it, just to see how changing settings might change the picture.

Lightening up

9 Setting the duplicate of the thumbnail to Lighten brings out some cool effects. I decide to go with this.

Metal or no metal?

10 I liked the Klimt-esque feeling of the glittering metal, but it felt too strong. Success! By importing a different scan of pyrite, I got the textures I wanted.

Final?

11 This was what I desired: a surreal take on drowning, maybe more like a bad drug trip than a fall overboard

Or final?

12 A friend suggested I integrate the figure more with the background. I decided I'd give the client both versions and let them decide which they preferred

Fantasy worlds

Epic vistas and vast horizons, gardens of paradise and dark satanic mills; your fantasy world can have them all. The choices you make when you design your world, its geography and weather systems, will affect how your characters live, work, eat and dress, so the decisions you make at the beginning of this process will affect everything that follows, down to the last detail.

Splash by Finlay

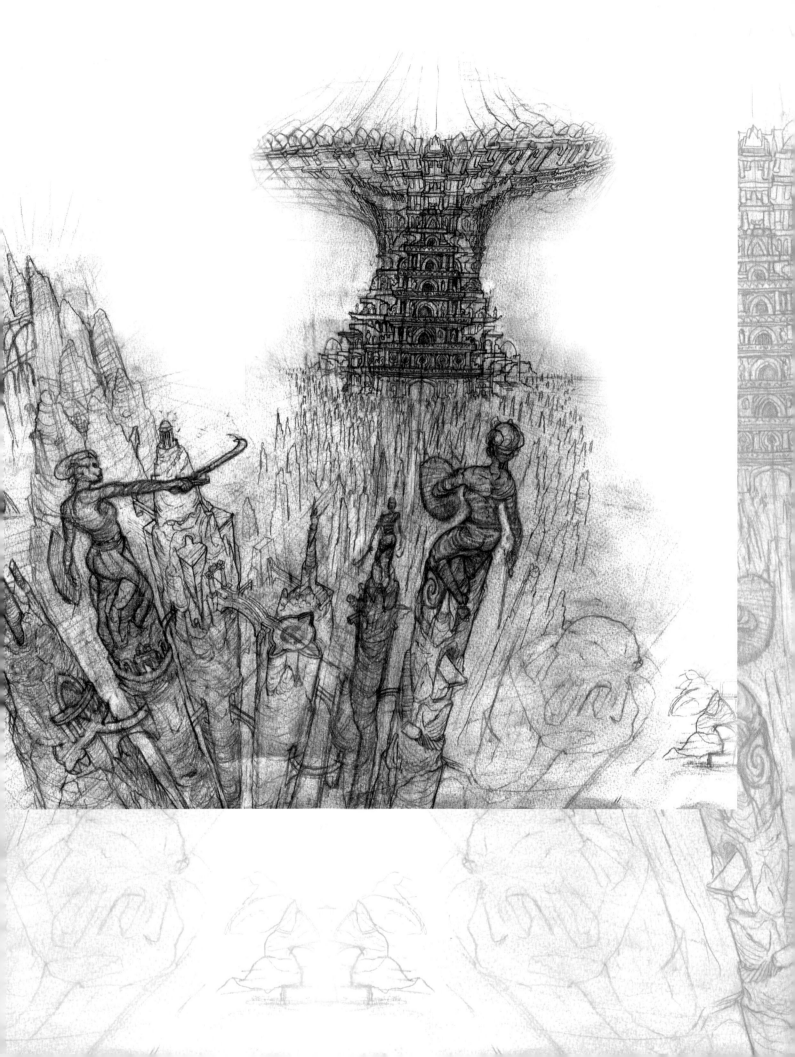

One- and two-point perspective

The methods used for creating perspective in drawings are absolutely essential for any artist. They allow you to create depth and foreshortening in imagery and can be used for people, plants and weather as well as buildings, machines and landscapes. Many beginners readily admit to being baffled by perspective drawing, but this is the kind of technical skill that is hard to learn at first but easy to master with practice.

One-point perspective

Begin by drawing the horizon line (HL) – this is the furthest point of the landscape that you can see, and is usually drawn parallel to the top and bottom of the page.

Add a vanishing point (VP). When you draw an object, you will see that all its horizontal lines will meet at this vanishing point.

Now try drawing several boxes. Note how you appear to be looking UP at the boxes that appear above the horizon line and DOWN at the boxes that appear below.

Most things are easier to draw in perspective if you put them in a box.

A series of objects of the same height will appear to get smaller as they near the VP. A line drawn from the VP will show you how high to make each figure.

Two-point perspective

Used for drawing objects that appear at an angle to the viewer, two-point perspective has two vanishing points.

Keep all the uprights parallel to the sides of the page; this changes when you get on to three- and four-point perspective (see page 94).

Use boxes for creating curved surfaces

The same rules apply to the foreshortening of clouds and mountains.

It's possible to mix the two types of perspective.

You can build any number of objects and buildings this way.

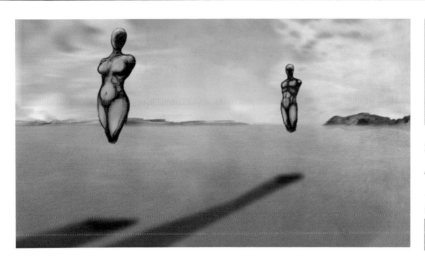

The use of perspective lines for the figures and their shadows can be seen clearly in this image inspired by the Surrealist art of Salvador Dali.

These 'before and after' drawings for the interior design of Café 1001 in London's Brick Lane show how curves can be put on perspective lines to create a 'fisheye' or wide-angle effect.

Echoes

The design for Pink Floyd's *Echoes* album was based on a simple idea that took full advantage of the effect of two-point perspective. This breakdown of the image shows how it was used to create the graphic effect of the 'windows within windows' idea.

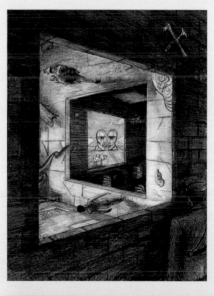

The design was also tried in a portrait format. This version played around with the idea of changing the planes relative to each other, reminiscent of famous designs by M.C. Escher.

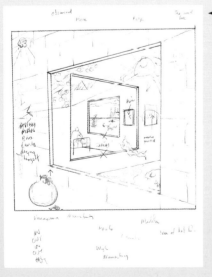

Numerous sketches were produced, trying out different elements from all the previous Pink Floyd album sleeves.

Under the direction of designer Storm Thorgerson, several different versions were photographed for the album: different covers were created for outer and inner sleeves, and variants for the vinyl release.

Three-point perspective

Three-point perspective adds a third vanishing point, which begins to make things more complex. Adding this extra point will affect the parallel uprights that you were using in two-point perspective. This technique is particularly useful for drawing extreme bird's-eye and worm's-eye views. In order to get the proportions of your buildings correct you may have to draw the vanishing points off the page, marking them out on your drawing board and using a very long ruler to achieve accuracy; with practice, you will be able to make these judgments more easily.

This is a typical two-point drawing.

Now see what happens when you add a third vanishing point: the object foreshortens downwards as well.

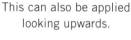

This can also be applied looking upwards.

Three-point interiors

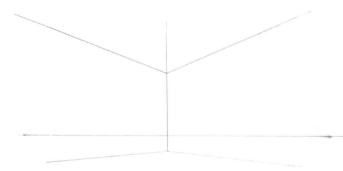

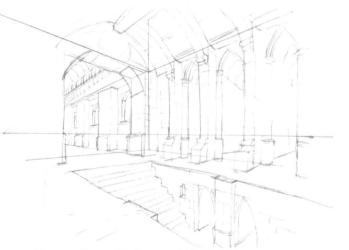

When you draw using perspective, you can begin with lots of lines to give you a feel of the space you are working with.

You can then add shapes within the room to define furniture and other objects.

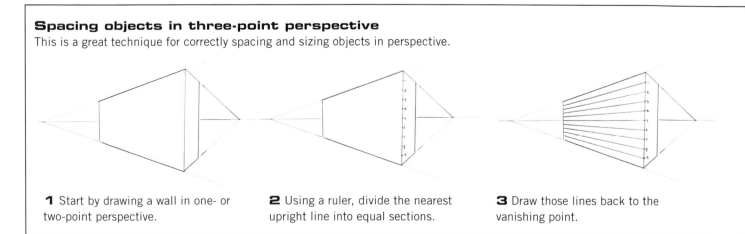

Spacing objects in three-point perspective
This is a great technique for correctly spacing and sizing objects in perspective.

1 Start by drawing a wall in one- or two-point perspective.

2 Using a ruler, divide the nearest upright line into equal sections.

3 Draw those lines back to the vanishing point.

Urban three-point

This drawing used three-point perspective to create a dense city. You can see from the construction lines how several blocks were created and sloped walls were put inside them. These sloping lines are part of the design of the buildings and are not affected by the vanishing points.

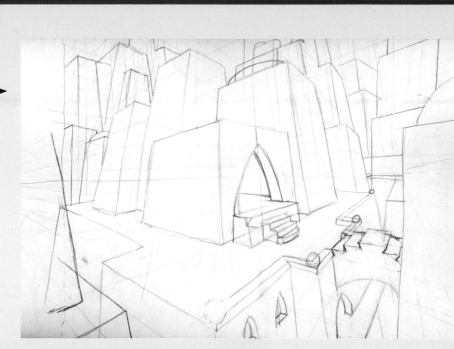

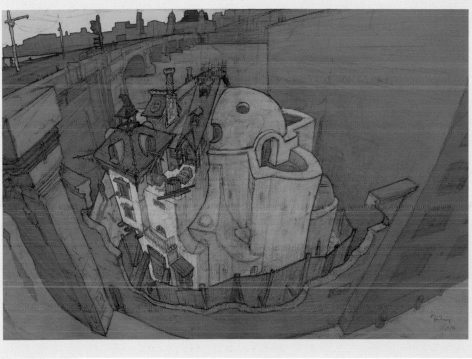

This drawing used the rules of three-point perspective but twisted the lines into curves to create a dramatic fisheye effect.
From The Memory War by Finlay

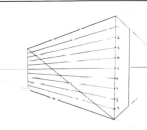

4 Now draw a diagonal across the wall.

5 Where the diagonal line crosses the horizontal lines, mark it off.

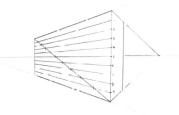

6 Draw uprights from those markings and you get the correct spacing as they disappear into the distance.

You can see how the spacing technique was employed in this sketch idea for Pink Floyd's *Echoes* album sleeve (see page 93).

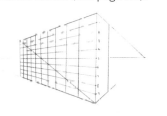

Classic architectural types

Most architectural visions have their basis somewhere in history; the trick is to draw inspiration from the existing world and then push your creations into the realms of the fantastic. This can be done by adding detail, such as statues and ornamentation, or scaling your buildings to enormous proportions. This spread looks at just a few of the many traditional styles of architecture from around the world that can be used as a starting point for your creations.

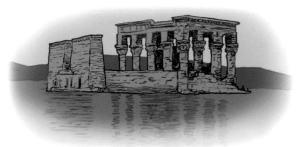

Aztec

The various architectural styles of South and Middle America are similar to those of Egypt in terms of their scale and achievement. The relief carvings and complex stone calendars have a particularly strong graphic style, providing a great source of inspiration for artists.

Egyptian

In ancient Egypt the construction of vast tombs and complexes was aided by the quality of the famous limestone that was available from the Mokkatam Hills in the north. The imposing character of Egyptian ruins, with their fascinating carved reliefs of animal-headed gods and goddesses, has been an enormous influence on fantasy artists.

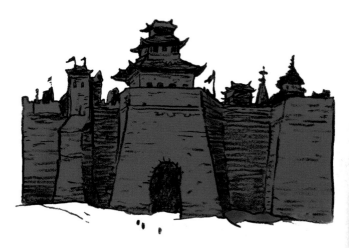

Chinese

Weather conditions such as the rainy season influenced this style of architecture, which features distinctive projecting roofs with steep sides to throw off rainwater.

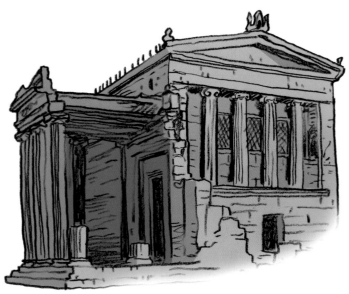

Greek

The harmony and proportions of Greek architecture were so effective that the same styles and building practices are still in use today. It is worth copying some classical Greek and Roman buildings in order to get a feel for good scale and proportion in building design.

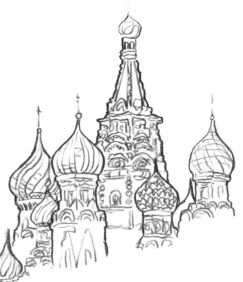

Russia

The highly distinctive style of these Russian spires is instantly recognizable and provides a great trigger for further ideas. Also take a look at Indian, Asian and Middle Eastern art and architecture for elaborate and exotic imagery to base fantasy architecture on.

Gothic

'Gothic' is a very loose term and doesn't really have anything to do with vampires and Tim Burton films. The term is generally used to describe medieval architecture in Europe between the 12th and 16th centuries, when the building style moved away from the clean lines of Romanesque design into the more ornamental styles seen on various churches and castles of the period. Gothic art and architecture are a rich source of ideas and embellishments for fantasy artists.

Mixing styles

The architecture in images such as this vampire village is made up of a mix of styles that has led to a new style in itself. Here we can see the heavy stone masonry of Gothic building mixed in with the half-timbered confections of Tudor design.

Vampire Village by Bob Hobbs

Cities

When it comes to designing a city in which your story takes place, try and imagine a single environmental or economic factor that defines it and makes it stand out from other locations. For example, one city could be surrounded by lava flows and draw its immense power from volcanic eruptions; another could be locked in ice, which would make it hard to conquer, but hard to supply as well. Each location in your fantasy world should have a striking personality – just like your characters.

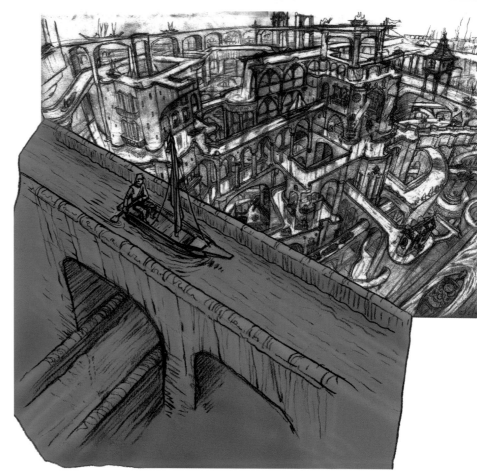

Canal city

A city of aqueducts where every passage is made by water. A city where the atmosphere is thick with the molecules of black water that are its life-blood. Even the skin pores of its merchant inhabitants ooze this rich, aromatic fluid.

The city prompts many questions: why does the water not drain away? why is it perpetual? how does it stay up? First, there are many water wheels spread around the city (they are silent and hidden), and a delicate balance keeps them in movement; the energy used and imparted by each wheel balances perfectly when added up across the city.

But ultimately, it is the inhabitants of this city who provide the momentum for the water: every time a person turns a tap or pulls a chain, opens a sluice or empties a bucket, the water is pushed this way or that and a little kinetic energy is imparted to a cumulative equilibrium that resounds throughout the metropolis. It is a fragile balance that would fall apart were it not for the simplest of things: every human sneeze, each single drop of sweat is essential to the perpetual life-flow of the City of Black Water.

From *The Memory War* by Finlay

Forest city

This city is built in the hollowed-out trunks of enormous trees. The trees themselves are of no ordinary shape, allowing the artist to experiment freely with the layout of the structures built in and around them.

Dryad City
by Anthony S. Waters

Inspiration

Look to shapes and forms in the natural world around you. Take tiny objects and increase them in size. Alternatively, take enormous objects, such as clouds or mountains, galaxies or forests, and diminish them in size. Look at manmade objects in your house or flat and imagine them as buildings with people living and working in them. Ask yourself how these people would survive? What would they eat and how would they keep warm? What would they make and sell, and where would they get supplies from?

Flesh city

Don't limit yourself to the usual materials of brick, wood and steel. In this case the artist was experimenting with a location made of living flesh.

Gut Canyon by Anthony S. Waters; © 2005 Hasbro, Inc All Rights Reserved

This drawing of a house for the Norse god Odin blends traditional Scandinavian architecture with a distinctive modern aspect.

Odin's House by Anthony S. Waters; © 2002 Microsoft Corporation; reproduced by permission

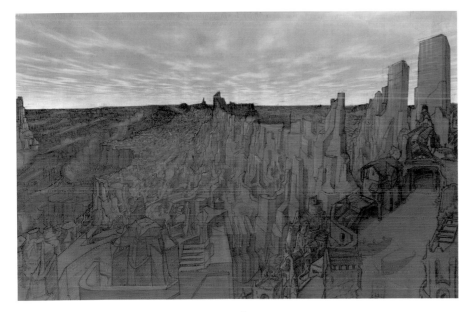

Steel and concrete super city

In this megalopolis, the buildings have become so large that they resemble the natural formations of the earth. On the left the building clusters form a 'grand canyon' and on the right they have grown to create an impenetrable mountain range that has split the city in two. In the foreground smaller communities have grown up along the ridges, creating the effect of a city on top of a city.

From Station to Station by Finlay

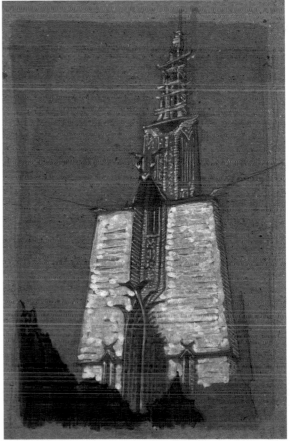

Buildings

When you design a fantasy building, think of the specific use it has in your world. Imagine what would be taking place in the building, and work out how this would affect the architecture. Try asking yourself some fundamental questions to guide you and make its design more interesting. How was it built, by hand or with machine tools? Where were the materials brought from? Is it a building that has to withstand attack? How many people inhabit it, and what do they do? What kind of weather does it have to stand up to? If you can find original answers to some of these questions, they can make your designs more interesting.

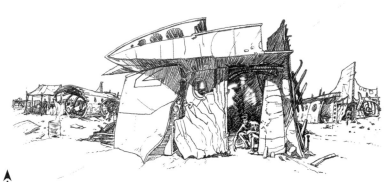

Shanty town

This rudimentary structure was clearly built by people living on the edge of society. What makes it interesting is the fact that it has been built from the components of crashed aircraft, which raises questions about the circumstances under which it was built.

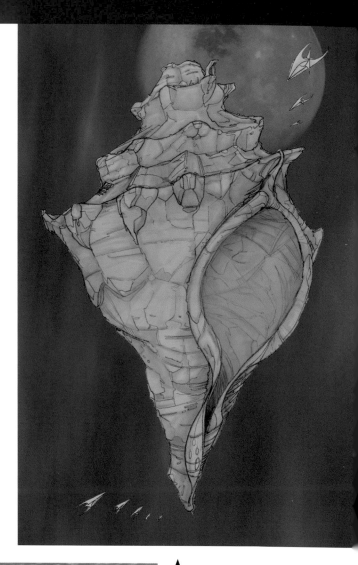

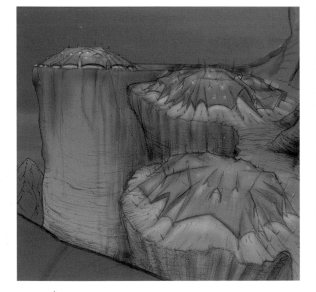

Tents

When designing a living space for a mountain-dwelling tribe it occurred to me that, being mountaineers, these people might be good with ropes, and this led to the idea of using huge communal tents occupied by several families. Wood would be in short supply in this environment, so tents make good sense.

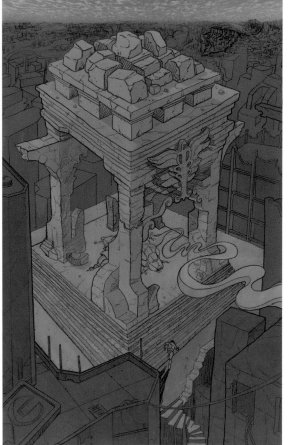

Skyport

When trying to imagine a floating starship I came up with the idea of using a giant sea shell constructed from the modern materials of steel and glass. The approaching ships give it the feeling of a bustling space port.

Temple

This building is a place of worship and is clearly based on Asian temple designs. Its architecture appears to be of ancient stone, and it stands in direct contrast with its immediate surroundings, the ruins of an advanced modern city.

From *Station to Station* by Finlay

Perching House

This unlikely structure is perched precariously on a mountain peak, It may seem implausible. but you can find a lot of similar buildings in existence around the world.

God House Rough by Anthony S. Waters; © 2002 Microsoft Corporation; reproduced by permission

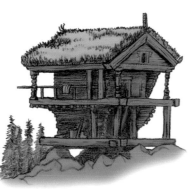

Tree house

This whimsical tree house was based on an existing structure in Papua New Guinea and its main purpose is clear: protection from wild animals and enemies.

Log cabin

This drawing was based on an existing building in Telemark, Norway. Wood is an obvious choice of material in a forest environment, as it is highly flexible and allows for some interesting design features.

Bender

This structure is known as a 'bender', and its construction is one of the simplest methods of building a durable shelter. It is built by taking a circle of supple living trees, bending them over and joining them in the middle. It was devised by semi-nomadic cultures because of the speed at which it could be constructed.

Wirewood Lodge by Anthony S. Waters; © 2005 Wizards of the Coast, Inc. Used with permission

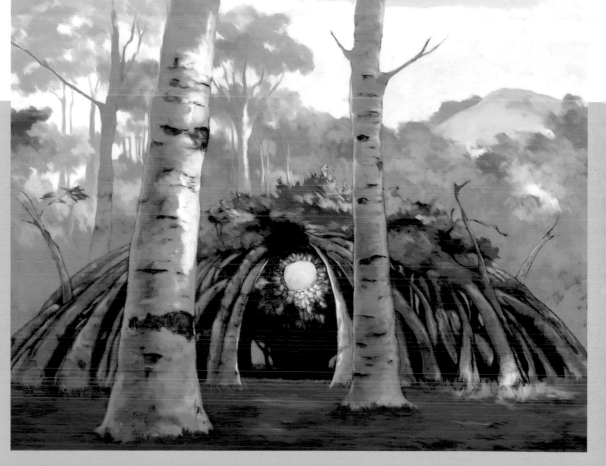

Cultural and economic influences

Cities, towns and villages evolve in different ways according to the climate, economic influences and outside influences, such as a need for defence against invaders. For example, medieval towns in central Italy were often built on hilltops due to the fine weather and a need for defence against Saracen raiders, whereas similar towns in Britain were built in the valleys partly because of inclement weather and partly because Britain is an island and had less trouble from invaders – apart from the Romans, of course, and the Vikings, and the Normans, and the Germans and the French ...

Industrial cities

A high degree of technological advancement gives the artist scope for wilder, more fantastic visions. Industrial cities tend to have a dark atmosphere, a symbol of the struggle between mechanization and the natural world. Consider what level of industrial development your fantasy world has reached, as this will affect how people trade, interact and fight with each other. This sketch was an idea for a poster celebrating Pink Floyd's 30th birthday and is meant to express the massive sweep of the music topped with light and delicate peaks.

Defensive towns

This is the most common type of city seen in fantasy epics because the innocent inhabitants of fantasy worlds are forever being invaded by the massed armies of dark lords and the forces of evil. Stout walls are a necessity for defence against medieval siege equipment but would be far less effective against artillery and other advanced weaponry. This example was based on a castle in Spain.

Market towns

Market towns usually grew up around a defensive castle into which the towns-people would retreat in times of danger. They are often found along river banks, as water was the most effective form of transport for many centuries. This version was based on a small town in Germany.

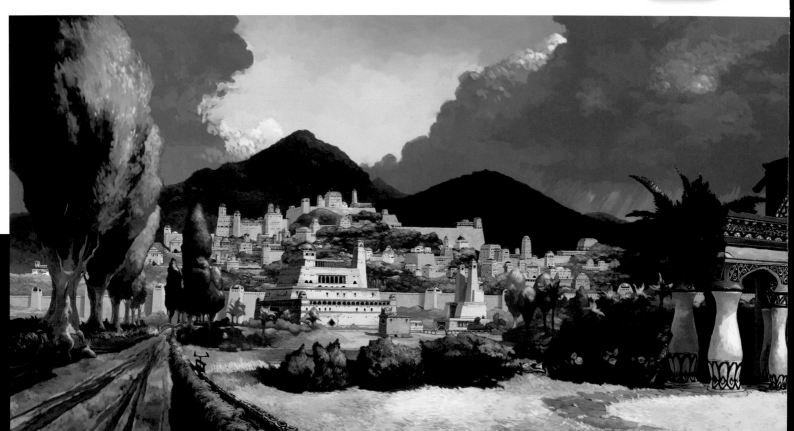

Walled communities

There is something appealing about the idea of a completely enclosed community that is self-sufficient. It is a microcosm of the whole world, and creating a place like this is rather like playing with a dolls' house. In this small paradise you will find greenhouses, workshops, communal eating and entertainment, and systems for managing water and the flow of supplies in and out of the buildings and gates.

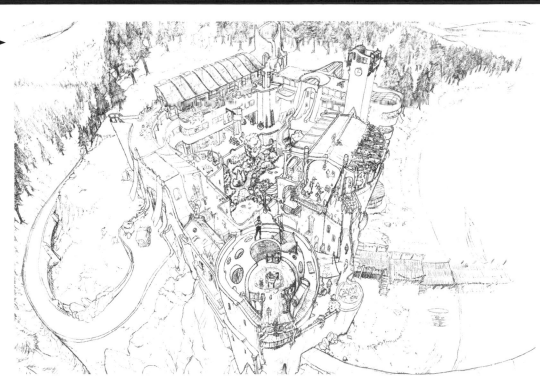

Pilgrimage centres

Magical cities in isolated regions would usually be trading outposts or cities that grew up along trade routes. In the world of fantasy they need not have a practical reason to exist – this is a mysterious city in an *Arabian Nights* fantasy. The perspective lines are used to direct the movements of wind and sand that seem to draw the traveller directly towards the city.

Religious complexes

This drawing was taken from Angkor Wat in Cambodia, a vast temple complex that has baffled archaeologists for decades. The purpose of the network of pools and canals surrounding the major temples is still unknown, but one theory suggests it is a vast map of the universe – a mirror of the heavens. When designing a religious centre such as this, be sure to include lots of statues, depictions of strange gods, goddesses and mythical creatures.

Tanyl

This city is obviously wealthy: the buildings are ornamented, and the design is based on a blend of Asian and South American architecture. We can see that this is a civilization at peace, as there is little need for defensive building. The lush greenery suggests an economy based on agriculture.

Tanyl by Anthony S. Waters

Trees and plants

These are just quick-fix methods to get you started so you don't get bogged down drawing every single leaf; you'll get to that later.

A large body of conifers
To give the impression of a wood seen from a distance, use a quick technique that doesn't involve too much detail.

1 Begin with some upright lines that follow the contours of the land.

2 Add dominant shapes to a few of the trees spaced apart.

3 Work outwards from the trunks.

4 Fill in the areas behind the dominant trees, working from front to back so the trees overlap. Add grass and mossy hillocks around the bottoms of the trunks.

Broadleaves
1 Begin with the shape of a trunk, then add several boughs in interesting shapes. Keep your lines quite light at this stage.

2 Add several clusters of leaves to get the overall shape. Make them overlap and leave areas where the branches show through the foliage.

3 Work into the leaf clusters using a consistent pattern. Break the general shapes up and make your lines overlap. Show some of the branches breaking into these areas as well.

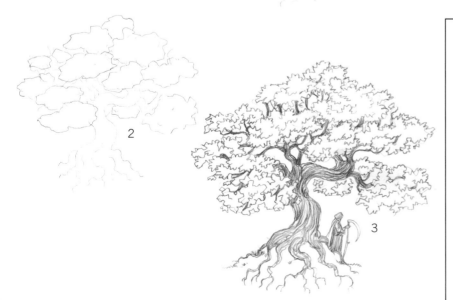

Flowers
It would be possible to fill a whole book on flower design, and you can have great fun inventing a wild variety of exotic flower types.

1 Begin with basic shapes.

2 Add stalks and ground grasses.

3 Finish off with detail.

Taking it further

There is a long tradition of plants as intelligent beings in the world of myth and legend.
Green Man by Anthony S. Waters; © 2005 Wizards of the Coast, Inc. Used with permission

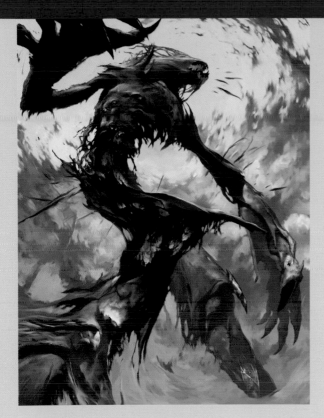

You can let your imagination run riot and invent whole new fantasy flora.
Stalker Bush by Anthony S. Waters; © 2002 Microsoft Corporation; reproduced by permission

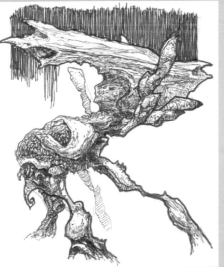

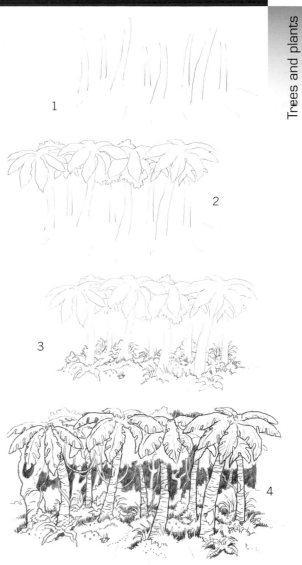

Tropical

Jungle and tropical swamp tends to have a lot more diversity, but it is still a matter of building up a consistent pattern of foliage that is pleasing to the eye.

1 As before, begin with some lines for the major trunks, in this case curved lines for palm-type trees.

2 Draw in the upper canopy of foliage. The trick is to cover the area with general foliage then have a few points of finer detail. Try and vary the canopy a little to suggest different tree species.

3 Now add a lot of different bushes and grasses at ground level. Note how many of these can be suggested with a few lines that cut across the bottoms of the tree trunks.

4 Add lianas in the middle space, leaving a few final gaps to put in distant trunks and shadows for an impression of depth. Go back over the other areas to add tone and detail.

feature: Illustration

It may seem unnecessary to study the principles of geometry, but once you have tried out the simple exercise on these pages you will develop an insight into the astounding proportional relationships between the basic shapes we are all familiar with. In the times of the ancients, such practices were considered almost divine in their nature – and after seeing it for yourself, you might understand why.

Geometry

Imagine a time before pencils and paper and rulers and compasses: a time when drawing was limited to scratching figures in the sand or on a cave wall. Then imagine that all the vastly complex drawings on the following pages could be achieved with the most basic of instruments: for a pair of compasses substitute a length of twine and a pin; for a straight edge, the string of a bow.

The amazing thing about the construction of the shapes on these pages is that no units of measurement are required, no degrees or complex calculations – it is all done by the process of subdivision and connecting points on a circle. This is in itself fascinating, but it becomes even more amazing when you remember that it was not invented by humankind – it exists purely and naturally in the world around us.

Rough designs

This feature includes a complex maze drawing based on Greek and Islamic geometric design. To begin with, I worked out how I would divide the greater image into a series of interlocking hexagonal sections; in the rough diagrams at left I tried a few different ways of planning the image before settling on the final idea.

I also played around with various different patterns that would appear within the maze, but I didn't have a clear idea of where I was going. I knew this was going to be difficult, so I spent plenty of time in the planning stage – I was cautious of leaping in and making life very difficult for myself further down the line.

Grid

The maze is constructed on a grid that is based on a simple system of geometric repetition. Creating a grid means that all the shapes within the bigger picture have relative proportions and there is an inherent harmony in the scaling of the image.

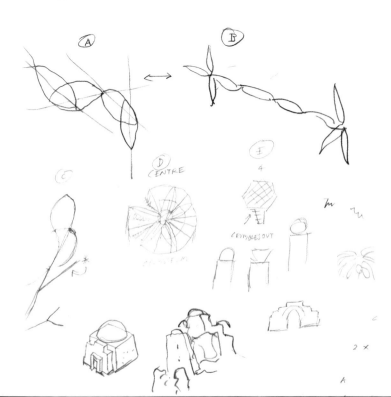

1 Begin by drawing a circle with a pair of compasses. Then use the radius of the compass to mark off around the circumference of the circle. You will find that the radius of a circle always fits into the circumference exactly six times. Wow.

2 By following through with the compass you will get a series of overlapping circles. You can do this again with all the outer circles, and soon you have a whole patchwork of overlapping circles that integrate perfectly with one another. It's that easy.

3 If you use a straight edge to join the intersecting points you can create a perfect hexagon, all done without the use of measurements or calculations. From there you can generate a perfect equilateral triangle.

4 And it doesn't stop there – a rectangle can be created without the use of a set square.

5 Now try different variations by joining the various intersecting points. Further subdivision generates smaller and larger triangles, which in turn allow you to create other shapes that spread off across the page. You can see a six-pointed star and other shapes appearing. Only a few of the possibilities are shown here, but on the following pages you will see many more.

And the method is so simple, a five-year-old child can do it.

Creating a city

Using the grid

A grid can be used as a guide to creating a city – city planners and architects generally use a grid of one kind or another. The geometric patterns shown here are just part of a vast number of different methods for creating endless tessellating patterns and shapes; all repeating patterns you see in art, textiles, architecture and computer design are built using grids. Even the pages of books like this and magazines are built on grids, and there are many different systems of 'harmonic' proportioning.

This grid shows all the different shapes I ended up using in the final maze. The hexagons join together, and you can also see how larger shapes crossed over the 'borders' of each hexagon. I began to test how wide the roads might be and how they would work in relation to the size of the buildings.

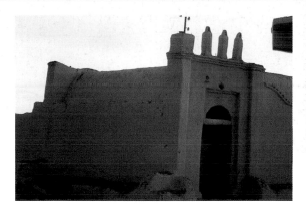

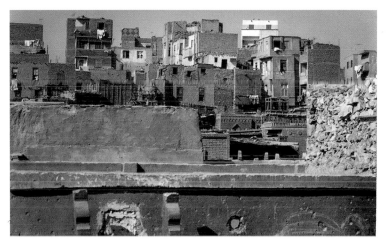

Putting any more detail aside for the time being, I turned my attention to the structure of the maze. I was working on a large scale: the drawing here was about 1m (3ft) tall. I put the grid on a large lightbox and began to create a maze by tracing off on to a clean sheet of paper laid on top. There was a certain amount of trial and error, but I kept problems to a minimum by identifying different zones in the maze, each of which would have their own distinct atmosphere and building style. At this point it was essential that I designed the network of paths in such away that it would work as a maze – not too hard and not too easy.

When I had finished the maze I flipped it over and turned it upside down and traced off another version in mirror image. This was to be the second half of the maze. The two patterns would be very similar and create a powerful symmetry across the whole drawing. All I had to do was make a few modifications to the pathways to make sure it still worked as a maze. Then I could begin the process of creating the city.

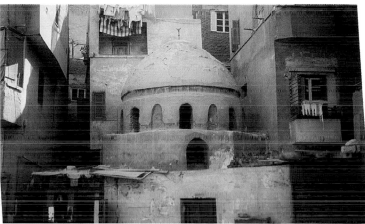

I began looking for buildings to fill my city with. I decided I wanted to do a maze based on my lifelong love of *The Arabian Nights*, so I collected together examples of buildings from throughout the Middle East; I decided to limit my search to this region so the overall look and feel of the city would be consistent. I also referred to my own collection of holiday photos taken in Egypt and Tunisia. The photo of the strange graveyard was taken in a place called the City of the Dead, a vast necropolis that sits outside the old walls of Cairo in Egypt. The City has been there for centuries, and even appears in *The Arabian Nights*. Over a long period of time people began to live there in makeshift houses, and it gradually turned into a town, home to 100,000 people, with stone houses, electricity and running water.

Digital colouring

Many months later I had finished the line drawing of the maze. By this time I was beginning to regret ever having started the project, and my friends and family were asking questions about my sanity.

Scanning

The drawing was about 2m (6ft) across, so it made sense to make the colour image the same size – which meant an enormous file size. At a professional repro house I had the original artwork photographed on a large-format camera, giving me two 25 x 30cm (10 x 12in) transparencies. The repro house scanned these on a drum scanner to ensure that I had the best possible quality. This gave me two digital files of about 300MB each.

I then spent a couple of days retouching the pencils in the computer. The beauty of digital is that you can get in very close to your artwork and clean up all the lines and aberrations in your original drawing. I ended up with a tight line drawing of about 600MB.

Colouring

Colouring a file this size was too much for my computer, so I divided the image into 16 panels roughly A4-sized (210 x 297mm/8¼ x 11¾in) which I coloured separately then pieced back together at the end. You can imagine what a nightmare it was making that lot match up.

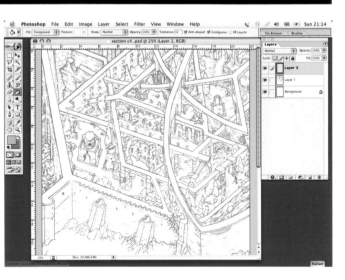

1 Working in Photoshop I created a new layer above the one with the drawing on.

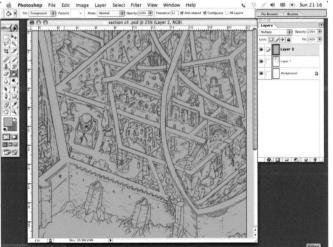

2 In order to maintain a consistent colour scheme I began by dumping a single colour over the whole image using the Paint Bucket tool. I applied 'Multiply' to the layer qualities on the layer palette, which allows the image beneath to show through.

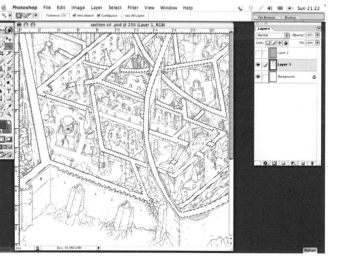

3 I then switched to the layer with the drawing on and selected all the paths using the Magic Wand and Selection tools.

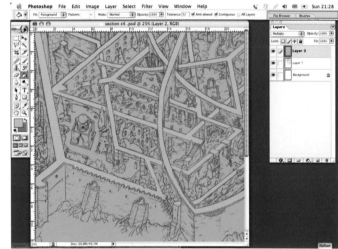

4 Then it was just a matter of switching back to the colour layer and using the Hue/Saturation dialogue box to change the colour of the paths.

5 The same process applied to every other aspect of the drawing. I would select an area with the Selection tools then change the tonal values on the colour layer.

6 I had to decide which walls would be in shadow and apply the same degree of colour change consistently across the entire artwork. It is possible to save colour settings in the Hue/Saturation dialogue box, so I had a whole range of settings with names such as 'ground', 'water', 'trees' and 'leaves'.

7 When the general areas were done, the image began to take on much more depth and form.

8 This picture shows the colour layer alone – and you can see how fiddly some of it gets. Bear in mind that this is just a fraction of the whole artwork and the colouring has just been applied to the main areas.

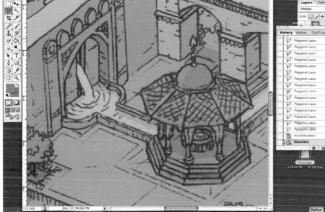

9 The general areas, such as the walls, paths and ground, were just the beginning. After these were completed I had to go in and colour all the details, such as tombstones, ornamental brickwork and drop shadows on any recessed features. I would select an area as shown here ...

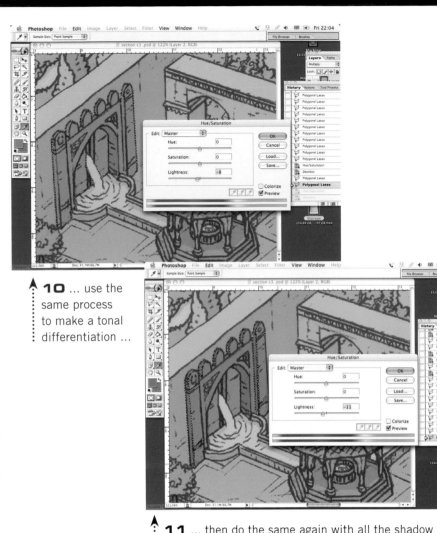

10 ... use the same process to make a tonal differentiation ...

11 ... then do the same again with all the shadow areas. You may wonder whether such an attention to detail really matters – but all those little elements have an effect on the whole. This is a general rule that applies to all artistic endeavours: the eye may not see the detail, but, subconsciously, it makes a difference.

Maze City

The final artwork can be seen as a whole and can be taken in at an instant because it has a strong, consistent shape – its symmetry, its colouring and its proportioning are all relative and harmonious, so it is initially quite easy on the eye. The viewer can then look further into it and enjoy some of the detail.

The aim is not to complete the maze but to just wander about this pleasant, silent city and see what you can find (needless to say, much of its quality is lost at the size it is reproduced here).

Many of the buildings shown here are based on existing buildings in the Middle East – from Isfahan in Iran to Souss in Tunisia, the architecture covers a vast geographic and historic range, so the picture has a vague educational value, not to mention that it is an exercise in Islamic geometry.

So what happens now? The image lies in a drawer waiting for a publisher daring enough to issue it as a print or a poster ... or maybe a jigsaw puzzle? Perhaps an oil-rich sheik will see it and have it transferred on to a floor in one of his palaces to amuse his guests and entertain his many children.

Ah well, we all live in hope ...

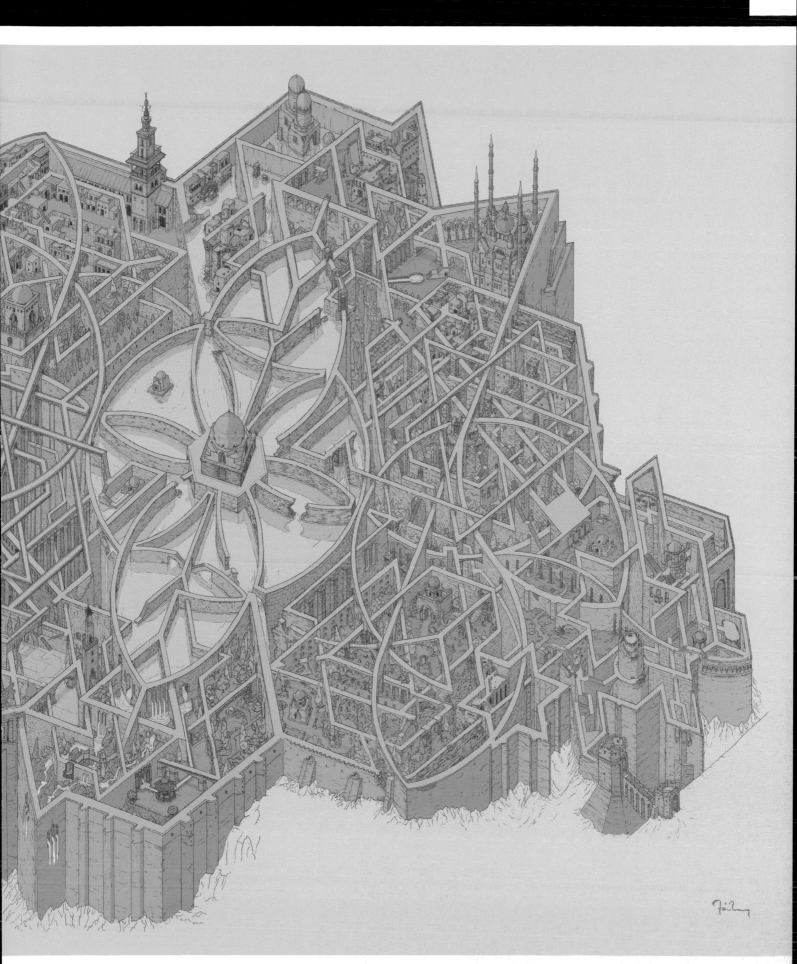

Media and outlets

Fantasy art and storytelling appear in a variety of media.
The largest markets are in feature films and computer games,
and there is a huge subculture of role-playing games (RPGs),
novels and comics. Fantasy art has also found its way into the
imagery of popular and classical music.

Producing a graphic novel can be an endurance
test, as the artist is required to write and
research the story, then do adequate
picture research to portray scenes accurately.
From The Indian Mutiny by Finlay

Graphic novels

For some years graphic novels have provided a
breeding ground for ideas and characters that
have grown into global franchises.
The attraction of graphic novels is
that artists can control their own
work and give life to their visions
without requiring huge budgets;
the fact that competition is just as
stiff as any other industry makes
no real difference.

Novels

After graphic novels, pure literary
forms such as novels seem easy.
There's no drawing involved,
and authors have the freedom to
meander into prose labyrinths.
However, like all creative forms,
novels are no easier than any
other if you want to create
something memorable.

Writing and drawing graphic
novels can help artists develop
useful narrative skills for
staging, pacing and setting.
*From The Indian Mutiny
by Finlay*

THE SOLOIST MARK SALZMAN

Book covers

Many designers and illustrators get their first break designing book covers. There is a steady demand for a wide variety of illustration and graphic styles, particularly in the fantasy genre. The work is not lucrative, but it gives artists much-needed exposure.

Picture by Finlay, Lou Smith and Ian C. Taylor

Music industry

The music industry has been a long-time employer of fantasy artists, and there are many genres that require both photographic and painted album sleeves. Like book covers, the work can give great exposure to artists.

Formulas

Although it's great to be a fan of the work of other artists, it's important to develop your own ideas. For this reason it is not always best to look to the genre you love for inspiration. It's a good starting point, but ...

When successive generations of new artists simply replicate and elaborate on the previous generation's ideas, the material and the power of those ideas begins to become stale and, the most dreadful thing of all, it becomes formulaic. In one way it is essential to stick to the tried and tested formulas of the genre, but it is equally important to evolve the formulas and give them new life. It is therefore necessary and enjoyable to look to sources other than the world of fantasy art for inspiration.

Film work ···▶

The demand for fantasy artists in the film industry can be enormous, as huge productions require artists with skills from architecture and costume to armour and modelling. Artists should consider developing skills in a specific area, such as set design or storyboards, as competition is stiff and employers look for well-honed skills. Prepare to be constantly cold-calling and sending portfolios to carefully chosen targets, such as art directors or prop designers who work in specific fields.

Rick Wright: Broken China Video by Finlay

Animation ···▶

Large animation productions require armies of animators. Despite the need for computer skills, artists are generally expected to be able to draw as well. Many artists work for large companies while producing their own, smaller scale work in their own time – short movies, such as this one, made for the 25th anniversary of Pink Floyd's *Wish You Were Here* album, can reach a huge global audience.

Picture by Storm Thorgerson, Mark Griffiths and Finlay

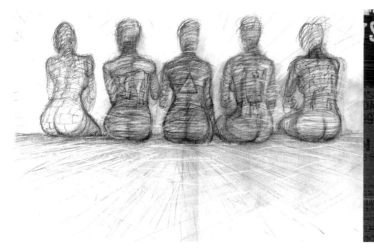

Ideas that start out as quick sketches, such as this one for Pink Floyd, can quickly become world-famous images and stay in the public eye for many years.

Back Catalogue by Finlay, Storm Thorgerson, Peter Curzon and Tony May

Survival

Finally, a few thoughts on getting through the day ...

1 Strategies

Focus

Most of us have a focus of one kind or another, but this varies enormously from person to person. Look at other artists or creative people and, by comparing yourselves and discussing your talents, determine where your particular area of focus is. Then play to your strengths while patiently working on your weaknesses.

For example, you may find you have tremendous patience when it comes to searching the Internet for information about software or reading manuals – that would be your focus. In contrast, I do not like manuals, so I have relied more heavily on my drawing skills than on being great at software.

Being productive

Remember this rule for the rest of your life: THERE ARE NO EXCUSES.

If you don't have a camera, download a picture; if you don't have a computer, paint a picture; if you don't have paints, do a drawing; if you don't have a drawing board, write a story; if you don't have a notebook, sing a song and use your memory.

By working with whatever is available or adapting to whatever situation you are in, you can develop the habit of being productive wherever you are. For example, if you are sitting on a bus, make sure you have a notebook or something to read; this may seem elementary, but grabbing these dead moments in a day can add up to an entire career over the course of a lifetime. Learn to be creative, and productive, wherever and whenever you possibly can.

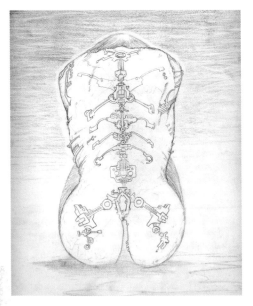

Robody by Finlay for Anthrax

Patience

Patience is a balancing act. Although it is very worthy to be infinitely patient and painstaking, we have to be careful that we are not just wasting time and deliberately stretching a job out so we don't have to think about what we are going to do next.

Then there is the flip side, which is equally sinister – we breeze through our work, convincing ourselves that it's good enough because the client doesn't seem to mind and our confidence (and ego) is boosted by the fact that we are getting paid rather well considering the hours we are putting in.

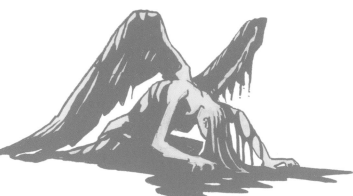

Oilslick Angel by Finlay for Audioslave

The answer? Learn to be critical of your own work and find a balance between unnecessary attention to detail and breezy self-confidence.

Networks

Although artists are usually quite happy with their own company, solitude and madness, they tend to build much wider networks than most other people. This is because artists are dependent on their social and business networks for their survival and consequently strike out much further than a person in a salaried job.

You may find yourself rubbing shoulders with entrepreneurs and lawyers: these are the people who will pull you up or give you a break, who tell you that one little thing you need to know or will make that one important insight that will change your approach to a piece of art or a project you are working on. It is important to cultivate relationships with people in all walks of life.

2 Obstacles

Frustration

Always give a job your best ... but if after a day or two you are getting nowhere, PUT IT AWAY and work on something else. The chances are, that by dividing your attention you will do another piece that is less frustrating, more satisfying and will refresh your energies for your return to the first job. You may also find that the second piece you were working on somehow gives you an insight that helps you with the first. This is an important method and helps loosen you up when you find yourself getting into a rut.

Time and money

Generally speaking, you will either have time but no money (and thus be unable to get much done) or money and no time (because you will be too busy earning money to get much done).

Sometimes you will find your time is taken up working as a waitress or petrol station attendant. There are two points to remember here: the first is that we have all had to do this at one time or another – even after periods of success, we must often return to more 'humble' means of earning a living. The second point

is: you may well find that working as an artist is more 'humbling' than selling petrol, which in turn might suddenly seem the more 'noble' of the trades. And for what reason should selling petrol be more noble, you may ask? Simple – you turn up, you work, you get paid, you go home. Art, on the other hand, is generally more nebulous. Time or money, you decide.

3 Success

Learning from failure

We attach shame and embarrassment to failure – don't. Accepting a certain amount of failure gives you the ability to be free to make mistakes and learn from them. If you don't learn you don't make progress, and if you don't make progress you don't get success.

Being able to deal with a little bit of failure also means you avoid some of the crushing blows to your confidence that come with it. Many people refuse to do things because they are 'afraid of failure'. Just bear in mind that every artist in the world has experienced the same defeats and setbacks as you.

Siamese Twins by Finlay for the Catherine Wheel

Coping with rejection

Nowadays, most rejection letters come with a cautiously phrased word of encouragement, but they still feel personal. You'll get used to it … you'll have to. The most successful people in all businesses get rejected, even at the top of their game. The screenwriter William Goldman had a smash hit with *Butch Cassidy and the Sundance Kid*, but then couldn't sell a screenplay for five years. You will always get rejected more than you get accepted – this is a certainty. By the same logic, it follows that the more you get rejected, the more your chances of being accepted will increase. The answer is to play the numbers game – pitch as much as you can.

your guns', you may never even get started. Focus on getting your work out there by whatever means you can; if you don't get seen, you won't get discovered. Always be on time, always make yourself useful and never make the mistake of thinking you're more important than anyone else.

Most importantly, do what you love and do it with love, and good things will come to you from the most unexpected quarters.

Stukahead by Finlay for Stukahead

Luck

You've practised hard, you've got talent and you've got a great portfolio. All you need now is the magic ingredient: luck. So increase your chances of getting lucky. You may find you have to give a lot away in the early stages and let your work go out for free – but if it gets you exposure, it's worth doing – up to a point. You may feel undervalued long after you are worthy of making a living from your art. However, if you stick too much to the philosophy of 'knowing your worth and sticking to

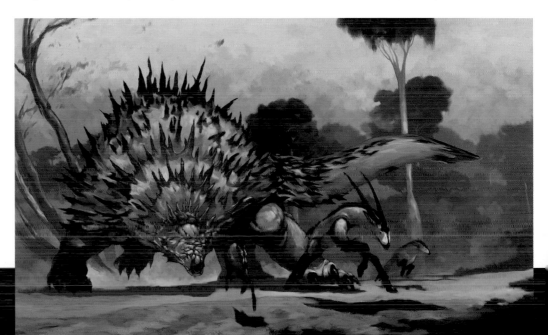

Credits and acknowledgments

Finlay Cowan

After a brief stint as bassist to Johnny Thunders of the New York Dolls, Finlay devoted his energies to design.

1993-2004 Worked as a designer for Pink Floyd, involved in every aspect of design from album sleeves to stage films and websites. Other clients included Audioslave, Jane's Addiction, Muse and the Mars Volta.

1998 His story, *The Memory War*, based on the history of café culture and esoterica, inspired him to build and manage the Moroccan-style 'Café 1001' in Brick Lane, London.

1999 A car crash compelled him to form the band Crash, which was later renamed Stukahead.

2002 Finlay and Nick Stone were commissioned by the BBC to develop an animated drama series which took stories from *The Arabian Nights* and transported them to present-day London.

2003 Worked as an illustrator in the armoury for Oliver Stone's production of *Alexander the Great*. Also the publication of his first book on fantasy art instruction, which went into seven languages.

2004 Set up Endless Design Ltd with Bill Bachle to manage copyrights, develop merchandising lines and undertake brand design assignments.

In his spare time he writes, continues to work with Stukahead and has taken up portraiture. He lives in Italy and London with his wife Janette and son Tyler.

For more fantasy art techniques, original art sales and limited edition prints, visit www.finlaycowan.com; also contact: art@the1001nights.com

Picture by Finlay, Storm Thorgerson and Nick Stone

Finlay's thanks to:

The Fellowship: Bob Hobbs, Anthony S. Waters and all at D&C.

The Warriors: Janette Swift, Anne Mensah.

The Mentors: Bill Bachle, Storm Thorgerson, Paul Claydon, Wilf Colclough, Mum and Dad.

The Magi: Jon Klein, John Watts, Lou Smith, Wes Maebe, Mark Griffiths, Dulcie Fulton, Annemarie Moyles, Mark Worden, Nick Stone ... and Tyler Swift-Cowan, Sam, Jasper and Tamsin.

The Angels: Åsa Lindstroem, Chiara Giulianini and Alma Fridell.

... and, of course, anyone who reads this book and gains something from it.

Anthony S. Waters

Anthony Scott Waters is a concept artist and illustrator based in Washington State, USA. His career has taken him from the early days of interactive software all the way to Hollywood, with many stops in between.

He's known as a monster maker and environment designer for Magic as well as companies such as Microsoft, Hasbro and Electronic Arts. His work has also been featured in *Spectrum: the Best in Contemporary Fantastic Art* and toured the USA in the MacExpo Digital Art Show. Most recently his work was featured in Spectrum 12 and Finlay's first book, *Drawing and Painting Fantasy Figures*.

Anthony lives in Bellevue, Washington, with his two dogs, Barnum and Ellie Mae. His work can be viewed at www.thinktankstudios.com.

Anthony S. Waters would like to thank:

Every creative has a ring of friends encircling them: a platoon of unpaid therapists keeping the artist from drowning in their own drama. I'm lucky to have them, luckier still that they will have me. There are many more than those whom I've listed below. I could fill up pages with names:

Mumi, my brother Chris, Rob and Susan Alexander, John Avon, Brian Despain, Lars Grant-West, Matt Harpold, David James, Jeremy Jarvis, Ava Jensen, Todd Lockwood, Mike Luce, Cara Mitten, Sky Rigdon, Helen Sanders, Brian Snoddy, Paul Sparks, Ron Spears, Scott Tolson, Scott Tracy, Whitney Ware, Kimberly Webster, Shane White, Kim Sharp, Darrell Richie, Finlay Cowan, Bob Hobbs ... and all those who remain to be thanked. Bless every one of you.

Bob Hobbs

Bob began his art career in 1973 and has created over 300 illustrations since then. His work has appeared in publications including *Amazing Stories*, *Talebones*, *Tomorrow Speculative Fiction*, *Pirate Writings* and *Space & Time*. He's illustrated the works of over 140 authors, games such as 'New Sun' by Steve Jackson, 'Citybook Five: Sideshow' by Flying Buffalo, and he was one of the original artists to design the first set of cards for the highly successful 'Legend of the Five Rings', formerly owned by Wizards of the Coast. His book work has included interior illustrations for *The Star Trek Concordance* encyclopedia by Bjo Trimble and L. Ron Hubbard's *Writers of the Future* anthology.

Bob has exhibited all over the USA, including two successful group shows at the Atrium on Park Avenue in Manhattan. He currently has a mural on permanent display in the Rayburn Building of the US House of Representatives.

Bob Hobbs's thank-you list:

I should like to thank Finlay Cowan, Anthony S. Waters, Deanna Caine, Sukie Baker, my family, all the other great artists I've met over the years, the Gods & Goddesses and my buddy Q.

Queen Ranavalona by Finlay

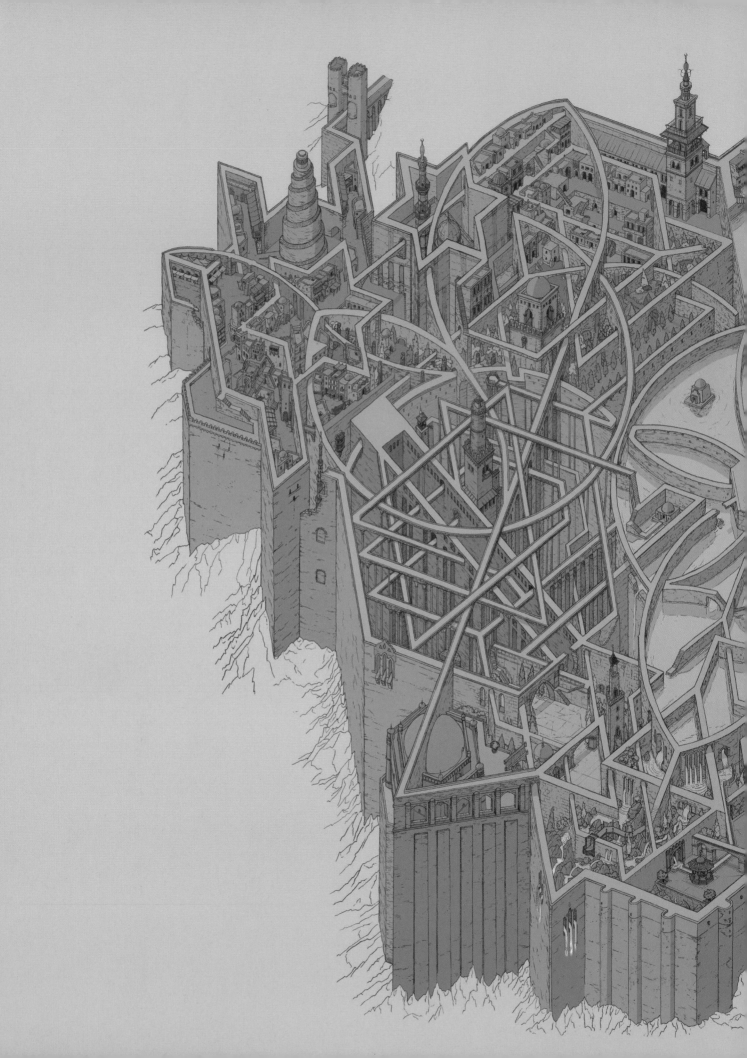

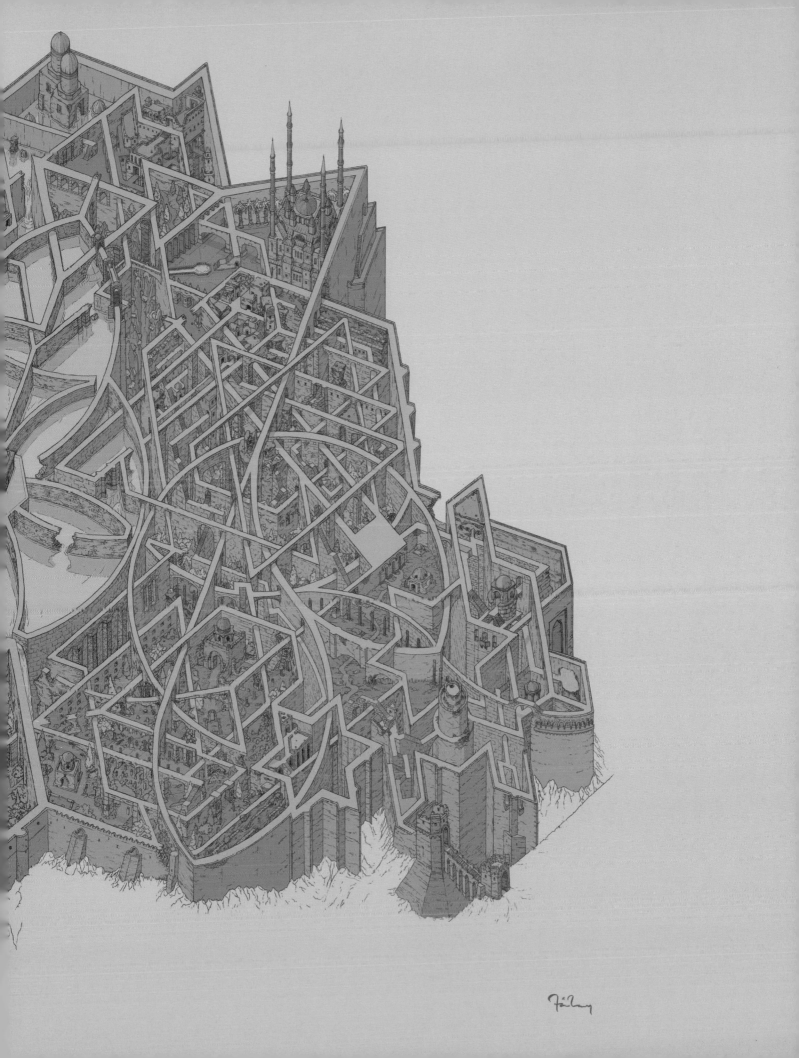